The Urban Ideal

Books by Paolo Soleri

Arcology: The City in the Image of Man
The Sketchbooks of Paolo Soleri
The Bridge Between Matter and Spirit Is Matter Becoming Spirit
Fragments
Omega Seed: An Eschatological Hypothesis
Arcosanti: An Urban Laboratory?
Paolo Soleri's Earth Casting: For Sculpture, Models and Construction
Technology and Cosmogenesis
The Urban Ideal: Conversations with Paolo Soleri
The Omega Seed Manuals: Collected Writings 1986-2000

The Urban Ideal
Conversations with Paolo Soleri

By Paolo Soleri

Edited by John Strohmeier

BERKELEY HILLS BOOKS
BERKELEY, CALIFORNIA

Published by
Berkeley Hills Books
P. O. Box 9877
Berkeley, California 94709
www.berkeleyhills.com
(888) 848-7303

Comments on this book may also be addressed to: jpstroh@berkeleyhills.com

Cover design by Elysium, San Francisco.

Manufactured in the United States of America.
Distributed by Publishers Group West.
ISBN: 1-893163-28-8

Library of Congress Cataloging-in-Publication Data

Soleri, Paolo, 1919-
 The urban ideal : conversations with Paolo Soleri / by Paolo Soleri ;
edited by John Strohmeier.
 p. cm.
Includes index.
 ISBN 1-893163-28-8
 1. Soleri, Paolo, 1919—Interviews. 2. City
planners—Italy—Interviews. I. Strohmeier, John. II. Title.
 NA9085.S6 A35 2001
 711'.4'092—dc21
 2001005148

Table of Contents

Editor's Note

For many years, students and admirers of architect/philosopher Paolo Soleri have been aware of the need for a brief, accessible introduction to his life and work. *The Urban Ideal* was published to fill this need. It includes the texts of seven conversations, recorded over the past three decades, that show Soleri's essential hypotheses and the evolution of his ideas during a period of extraordinary creativity and achievement.

The conversations are presented in roughly chronological order. The first two, which took place in 1995 and 2000, serve as an introduction and represent an overview of Soleri's most recent thought. The five that follow show the development of his ideas from 1973 to the present. While these conversations include redundancies (notions such as frugality and complexity, for example, are explored in several interviews), each takes place in a unique context with participants of varying interests. As a result, ideas unfold in new ways, in greater depth, in successive situations.

Although Soleri has been recognized as a public figure for nearly half a century, the fact is, as he notes, that he withdrew to the Arizona desert as soon as he established himself in the U.S. in 1956 and has pursued his work since that time in a relatively reclusive fashion. The lessons he has to teach about the nature of habitat, humanity, consciousness and compassion, however, are perhaps of immense value to us and future generations. In them may lie original keys to a more desirable evolutionary path. *The Urban Ideal* will achieve its purpose if it succeeds in introducing these lessons persuasively to a wider audience.

For their generous help in producing this volume and their hospitality during my visits to Arcosanti, I want to thank Tomiaki Tamura and Mary Hoadley. I am grateful for the help and promptness of Cosanti

Archives Manager Jeffrey Manta. I also want to acknowledge the encouragement and kindness of the Arcosanti residents, particularly the Arcos family — Victor, Luz Adriana, Paolandrea and Victor Manuel — David Tollas and Nadia Begin and their son Tristan, and Sue Anaya. Above all I want to thank Kathleen Ryan, whose hard work and perseverance have insured that Soleri's ideas will reach the larger audience they deserve.

Preface

BY JEFFREY COOK

1. Paolo Soleri's urban ideal has a simple and timeworn premise. Soleri believes that people are social animals, and that the city, designed for human discourse and intercourse, is their appropriate habitat. Thus he honors man, *homo sapiens*, the single surviving primate, distinguished by self-conscious thought processes coupled with contemplative and engaging intellectual prowess. But Soleri also respects action-man, *homo faber*, the toolmaker, the fabricator, who transforms his natural environment into an increasingly man-made environment. Soleri has focused his creative life on design theory for ideal human social habitats.

2. Soleri's life view is grounded in his southern European childhood between the two great world wars of the twentieth century. Important in Soleri's background is the influence of the rise of Italian Fascism during his formative years. More subtle was the influence of shifts in Italian Roman Catholicism during that period. Soleri's religious exposures were sufficiently embedded that his later discovery of the writings of the French Jesuit philosopher Pierre Teilhard de Chardin was life confirming.

3. Soleri's appreciation of the city is straight from Mediterranean Italy. Urban life around the Mediterranean is a continuous public drama, with its daily and seasonal ebb and flow of people's comings and goings and all the interactions between. This gregarious play of humans, in which audience and actors are one and the same, has its social roots in the ancient Mediterranean cultures of Greece and Rome, cultivated by time in provident lands and climate. It is in the thriving detritus of those cultures that Soleri learned living human values. But his childhood vision of a fantastic and brilliant future was romantically projected through American movies and periodicals. His transport to the hard

realities of the New World was to the harsh geography of the arid American southwest, to the swinging, dry air temperatures of the Arizona desert with its moonscape vistas, a polar human cultural counterpart to the frenetic automobility of the American way of life.

4. How could Soleri's body of ideas, based on economy, frugality and social conscience, emerge and be sustained within the U.S., characterized elsewhere as the most consumptive and indulgent nation on earth? Potentially, it is this New World context that continues to promise a brighter future, and the American way of life has fueled Soleri's ideas. For almost a half century, he has lived on five acres in the town of Paradise Valley, a high-end, lowest density "residential only" enclave next to Phoenix, Arizona. Soleri is living during the times of, and in the midst of, the American dream house — an oversized isolated family home ideally situated as a retreat in some rural landscape. This pastoral but nonproductive seat is served by an oversized automobile giant. Both are mechanically strident as they respond to every human whim. Self-identity and social worth are tied to visible, marketable, luxuriant extensions of expansive appetites.

5. American saturation advertising promotes not cities, but its fragments in the suburbs — indulgent houses and multi-ton automobiles. These consumptive machines are supplied by resources brought from greater and greater distances. Simultaneously, American multifamily and high-rise housing has been totally discredited socially, except for the very wealthy, who also appear to be the only Americans thriving in selective dense urban enclaves such as can be found in New York, San Francisco, and other cities still considered worth visiting. But for the general public, Americans have almost pathological responses to the term "density," which is a prime precept of Soleri's rich life projected in the qualified "thick of things."

6. Soleri's urban ideal includes the propagation of great institutions — universities and art galleries, symphony orchestras, theaters and librar-

ies. He talks about these markers of civilization that enhance and propel quality of life. But Soleri's personal perceptions of urban pleasures are private, endless, intricate and mostly unspoken. From the slow-motion civic observations of trees growing, babies born, playing, flirting, coupling and producing new families, to the instant snaps that replay the familiar with ever new appreciation; the vividness of fountains splashing, the rounds of the neighborhood dogs and cats, the dependable taste of coffee at the neighborhood dive — these are the constant pleasures of sensual renewal that are magnified in an urban setting where friend and foe rub shoulders. But this is not a setting for a suburban drive into town on a Friday night. Soleri's urban ideal is a day-to-day life for the integrity of a continuous sense of the best of what it is to be human. The ideal is its enhancement. Although traditional cultural corporations like museums are fundamental, Soleri's true theoretical urban institution is the perceptual succor of the individual.

7. Soleri belongs to a continuation of the Heroic Period of Modern Architecture, both by line of continuity through his mentors, and because of his content and commitment. Soleri's own first architectural hero, admired as a student from a great distance, was LeCorbusier (1887-1965). The propagandist of Modernism, LeCorbusier demonstrated revolutionary thinking and action. He wrote, "We have to rediscover Man. We have to rediscover the line that blends the essential laws of biology, nature and cosmos." LeCorbusier's models, whether of a rural one-family house like the 1929 Villa Savoy, or of a whole urban fabric such as his 1931 design for Algeria, were of liberation from the land. Giant columns, or *piloti,* and orderly platforms separate the man-made from nature, and allow nature to continue uninterrupted.

8. But the Modernist hero most closely associated with Soleri is Frank Lloyd Wright (1867-1959), under whom he worked for over a year. Among Wright's many lessons was the importance of design integration. At all scales, all components should be extensions of a whole building concept, even intimate objects such as table settings. Wright's mod-

els also fused the natural and human environments, where the man-made extended and heightened appreciation of the natural world. Wright's "organic" philosophic passion, based on interpreting the lessons of nature, is also part of Soleri's dedication.

9. Soleri uses a Modernist and non-historical architectural vocabulary. More importantly, he embraces the socioeconomic program of the Modern Movement. Thus, while many leading architects in the last quarter of the twentieth century abandoned both the vocabulary and social charge of Modernism, substituting a pseudo content and expression, Soleri optimistically continued and extended the reach of Modernism in all aspects. Both new construction materials, and the new tools of knowledge and manipulation such as computers, were embraced at the same time as he engaged concern for global poverty, human degradation and resource depletion. Soleri's heroic stance as a champion of humanitarian causes is not all pretty or endearing. Most of these causes are unfinished business that originated with the values operative at the beginning of the Industrial Revolution.

10. Soleri emerged as an international architect of ideas in the midst of efflorescent constructive manifestos that countered the devastating tragedies of two world wars. In that optimistic postwar generation after mid-century, when thinking primates put one of their species on the moon, there was also a wave of material positivism regarding how multinational industrialism could indeed provide for substantial lives as well as materialize dreams for ordinary people. Soleri's noble goal of "an environment in harmony with man" emerged as part of that climax of generic idealism based on industrial capitalism that spanned from Bucky Fuller's first Dymaxion House of 1927 through the end of the 1960s.

11. That period was documented by Reyner Banham's 1976 book, *Megastructure: Urban Futures of the Recent Past,* which examined a particular type of oversized multifunctional building with interchange-

able parts. It was the last wave of modern constructive projection — a swan song of superstructures. Soleri resented inclusion in this international company of 1960s architects proposing monumental structural frameworks where whole communities would contrive their own environments. The first words in Soleri's 1971 book, *Arcology*, were, "This book is about miniaturization."

12. Banham included Soleri's work in the conclusion he called "Dinosaurs of the Modern Movement." But now in a new millennium Soleri alone persists heroically in the viability of his original vision, as shown in these three decades of interviews. The difference is that aside from visibility of the structure, which is fundamental to any architectural image, Soleri has a profound social agenda and a convincing environmental commitment. These are the substance of his conversations. Thus, with Soleri, there is a continuing danger of confusing the object with the idea.

13. Although he is powerful in both, Soleri's verbal propositions have sometimes been separated from their diagrammic analyses, or from their architectural imagery. But for stunning graphics, Soleri's masterful book, *Arcology: The City in the Image of Man* (1971), continues to be one of the great books of the twentieth century, with the graphics of its architectural thunderbolts. Although little of consequence got built or perhaps influenced by that book, it is a genetic, graphic seed package, in all its naivete, for forthcoming millennia of consciousness regarding the design of human evolution. And if those images seem threatening, Soleri himself has often volunteered to separate his theoretical propositions from his architectural proposals, which he regards as amateurish. He believes it is his philosophical discourse for which he should be best remembered.

14. Architecture is an art of substantial materiality. It is our obsession with materiality that Soleri insists is threatening our natural habitat on earth. Increasingly, scientific monitoring is confirming Soleri's random

observations. Soleri deals with that materiality by establishing conscious ethical priorities. He insists they are essential, not for the survival, but for the evolution of the species. The consistence of his commitment to frugality does not restrain him from proposing big moves, among the most ambitious that any lone *homo sapiens* has ever imagined.

15. Mixing the container with its contents is especially risky because of the memorable and convincing appearance of Soleri's architectural designs. Already in 1963 Soleri was honored by the American Institute of Architects as a craftsman, a formgiver with his hands. Soleri's urban idealism has a programmatic correctness that seems to harken back to the ancient Greek quest for perfection, for a fitness of universal harmony. Soleri's motives are similarly noble. He continues to ponder the great human dilemma of identity and worth: How shall we live? But our times are much more complex. And now the democratization of knowledge is more complete than it has ever been. Sometimes with awkwardness, Soleri examines and articulates the human condition and its potential. He is not so much a scholar, locked into ritual, definition and pattern, but a philosopher, with perishable methods and open-ended inquiry. Thus his is not a hermetic plan. There are many unsolved questions, many issues without recommendations, and countless details without an outline. Soleri allows his own imperfection and incompleteness so that we might take these ideal goals to a higher level of resolution. The burden is shared. There is more than he can do or imagine.

Tempe, Arizona
August, 2001

The Urban Ideal

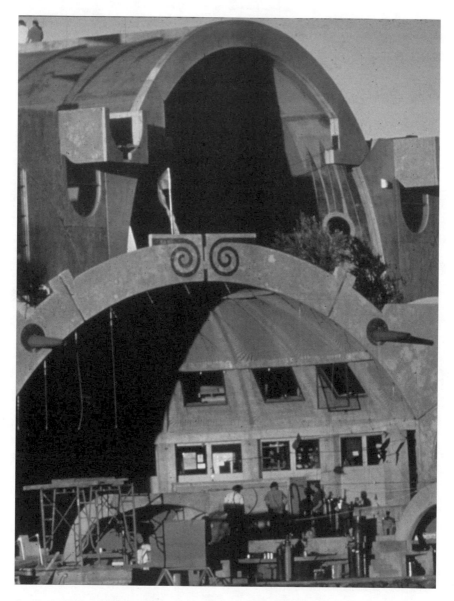

Central Vault and Bronze Foundry Apse at Arcosanti

Beginnings, Ends and Means
An Introduction

"I believe we live in a very powerful, very harsh, and very indifferent reality. And if we can begin to work into it, and work into it by way of compassion, of generosity — all those things we invent —that's our greatness."

This conversation between Paolo Soleri, and editors John Strohmeier and Kathleen Ryan, took place in December, 2000, in Soleri's apartment at Arcosanti, near Cordes Junction, Arizona. It serves as a short introduction to Soleri's work, showing its roots in his philosophy and life experience.

* * * *

Soleri: To start at the beginning, I was born in Torino on the twenty-first of June, 1919. That's the longest day of the year, the solstice. And my name, Soleri, means, "You are the sun." In Italy, we are all the sun. We are all the sons of the sun.

JS: So it doesn't make you someone special.

Soleri: No, we are all sons of the sun. It just happens my name confirms that. My family lived in an apartment very close to the center of town — myself, and my parents and a brother and sister, and then we always had cousins. My mother's sister lived very close, so in a way I also grew up with three cousins. Torino, at that time, was an automotive city. It had been the main industrial city in Italy for more than a century; now it's become even more so, because of the presence of the main Fiat factory.

JS: It sounds like Torino was on the same timetable as Detroit. Detroit was a jewel of a city in the 'twenties and 'thirties.

Soleri: The qualification is that Torino arrived earlier as a baroque town. So it has a history. It goes back to the Romans. We had ruins from the Roman period. It didn't develop quickly through the Renaissance and so on, but it developed a character later as a principality, a small country including part of France and part of Italy. So it was in some way a kingdom.

JS: So the city in the 'twenties had baroque architecture as well as modern.

Soleri: Yes, Torino was planned during baroque times, when the economy was quite prosperous. The plans were very good.

JS: And did industrial wealth bring in a new wave of a different kind of architecture?

Soleri: Well, that was the beginning of the rational school. You know Cubism, perhaps Cubism as in art, and so on.

KR: At a young age, did you think that architecture was in your future?

Soleri: No. My family wasn't wealthy. My father was one of five or six siblings. The two younger ones were looked down at, that might be one reason why my uncle came to the United States. And then he asked my father to come. My father came and couldn't take the system here, so he went back to Italy. He was a bookkeeper for a while for a chocolate company, and then he tried to branch out on his own, working on electrical appliances. He worked on heating elements for stoves and so on, and had some success there. Then he moved to France because he couldn't take the Fascist regime. He went by himself at first, traveling back and forth, and then he decided the whole family should move there. But that didn't work out. We were there over a year and then we had to come back.

JS: Were you already in school when you went to France?

Soleri: I was in secondary school and then I registered in the Ecole d'Art Industriel in Grenoble. I was there one year. This was a fine arts school,

which I chose rather than one of the classical or scientific schools. There I studied the history of arts, and the actual use of skills in designing — mainly copying. Then I tried to decide what to do — to go into engineering or to go into fine arts, the way into architecture. I took architecture.

JS: And was that a simple decision?

Soleri: I don't remember, but I guess it was. I went to the Torino Politecnico, and completed my Ph.D. in 1946. I would have finished sooner, but the war came in 1941 or so, and I took time off to serve in what was called the General Corps. We were in charge of maintaining things — patching up roads or bridges, camouflaging. It was in the Alps. It was so cold your hands would freeze when you started to hammer or something. After that my group was stationed near Cannes, St. Tropez, and that area. We were just sitting there. So I would get my visa out and take a bus to Nice, for instance.

Then in 1942, the first Fascist regime collapsed and I became a nonperson. The army didn't dismiss anybody. The army just collapsed. And so everybody was on his own. I happened to be not far from Torino, so I got onto a train in my shorts and my sandals with a box of books I collected, mainly in Nice, and went home. And from there on until the end of the war, I was a nonperson.

JS: Which means you weren't involved in school?

Soleri: No, I kept going to school, but I refused to enroll because it was dominated by the new Fascist regime, which Mussolini and his cohorts had established under Nazi guidelines. For two years I didn't take any exams and I had to risk being arrested. I was so lucky that I was never picked up, because they had forces who would take a section of town and come in with trucks and so on. They would collect, number one, all the young people who could be workers in Germany, and number two, the Jewish who could be deported. When I finally got my doctorate degree it was 1946; the war had ended, and I was again a citizen.

JS: Was life hard for people in Torino because of the war?

Soleri: Well, yes, but nothing comparable to what was going on in other countries. We never really suffered, even though we didn't have any food stamps. We ate bread that was part plaster, and part flour, and part anything. We were rationed. But there was no question of famine.

JS: Let's talk about school a little bit. When we looked at the musician's house drawings you did in school and the other pieces that you showed us from that period — it is not only the designs that struck me, but the kind of care that went into the presentation. It was as if every aspect of the project, not only the drawings, but also the handwriting, the mounting, the packaging, and the sequence — every aspect is envisioned and executed to a kind of perfection.

Soleri: Yes. It was even then important to me to package ideas and graphics in certain ways that were not perhaps commercially feasible, but that were a blessing, so it seems, to myself, to the professors, to the students, and so on.

JS: After graduation, did you expect to establish yourself as a professional architect in Italy?

Soleri: When I completed my doctorate, I mentioned to the dean that I was thinking of coming to the States, and that I had written to Frank Lloyd Wright who invited me to visit him at Taliesin. So at the commencement, as I received my degree, the dean gets up and he says, "Paolo Soleri, a very good student," and so on, "has been awarded a four-year scholarship." (It was actually one-year.) "And this will make it possible for him to go to the States." The funny thing is that the four-year scholarship he referred to bought me exactly four and a half pounds of butter because of the collapse of the lira.

KR: So how was it that you first came to Scottsdale and Taliesin West?

Soleri: I discovered a small book about Frank Lloyd Wright in one of the bookstores in Torino. I don't think I knew anything about him be-

fore then. Outside the U.S. he was known mainly in central Europe, I think, and in Japan, naturally, because he'd traveled there. I found Wright's work very — it was almost shocking, but I liked it a lot. So I wrote Mr. Wright a letter, and then I think something like six months went by. I forgot about it, and then I got this letter back, an invitation to Taliesin West.

I left Torino in 1947 and embarked for New York. I sailed from Genoa. The journey by ship was about four days or so, and then we got to New York. They put us on Ellis Island where everyone was divided into groups and investigated. For many days I didn't know where I was or why I was there, and then I was called in by a commissioner. He questioned me in Italian, and to this day I don't know exactly why I was detained there for thirty-five days. My guess is that they wanted a bond. I know that my uncle, who was in Santa Cruz, deposited five hundred dollars so that they could deport me if I tried to stay. That was probably the main reason. The other reason may have been that the Frank Lloyd Wright Foundation was seen as pinkish because they had connections with Russia.

KR: Was that correct?

Soleri: They did. But the connections were definitely not political. Mrs. Wright was a friend of Gurdjieff, from Russia. He was a guru — not a holy man, but a guru, and a very powerful guru — and he used to visit quite often. Perhaps that indicated to someone an orientation toward the Communist cause or something. I'm just guessing. Eventually they gave me a pass for forty-eight hours to see New York a little bit and a train ticket to Santa Cruz where my uncle was.

JS: Santa Cruz must have just been a little village then.

Soleri: It was. For me everything was really something to behold. My uncle was living in a hilly section, so it was quite a beautiful landscape, somewhat like Italy. From there I took a train to Phoenix. And then, not speaking any English, I kept saying to I-don't-know-who, "Taliesin.

Taliesin." Somebody in Phoenix put me on a bus to Tellison, Arizona, which is in a flat land of farming. So I had this notion of the hills, and the cactus, and so on, and here I was in the middle of, you know, citrus trees. I was in the wrong place. So finally, someone understood that I was going to Taliesin. I came back to Phoenix and then somehow I ended up there.

When I arrived Taliesin West was a camp in a valley — the winter quarters for Wright's fellowship. He had his residence, and a drafting room, and then a little theater, and so on. I was there for eighteen months, sleeping every night on an open-air platform on the hillside with the other junior architects. Then we left Taliesin, myself and a friend of mine, and retreated to Camelback Mountain. I lived for three years altogether without a roof over my head. The desert winters were pretty cold, but at that age, you don't mind, especially if you enjoy the outdoors.

JS: So, then, you were a junior fellow for the entire period with Mr. Wright?

Soleri: Yes, in part because for the first six months I couldn't communicate with anyone but two or three of the fellows. I developed a good friendship with a young architect from Jerome, Mark Mills, and another who spoke some French, so that we could communicate a little.

JS: During that period, did you apprentice on architectural projects?

Soleri: No, I never got that far. I was assigned kitchen work half of the time, and construction for the rest, so one week I'd be kitchen help, and then another week I'd be building things.

JS: Did you grow as an architect?

Soleri: It wasn't so much a conscious architectural learning process as an absorbing experience. I was a sponge and, perhaps, not a very good sponge. I was absorbing the desert, and what I might be able to do in the desert, how I might surround myself in that kind of area. Nevertheless, Mr. and Mrs. Wright were both very highly considerate of me. One

reason was that I was a very good servant. I would serve the meals. I would do flower arrangements every day for their table. It was a very nice relationship. But I was still new in terms of language, so I would only be in touch with Mr. Wright at breakfast, lunch, and dinner.

JS: What then initiated your departure from Taliesin?

Soleri: Well, the first issue was perhaps my telling Wright that I liked so much my experience there that I wanted to try to recreate it on my own. That was fine. He expressed a very positive feeling about it — even suggesting that he help me somehow. Then in a matter of a few weeks, three of his senior people came to him saying, "We would like to go with Soleri to Italy." Well, that made him resentful, I'm afraid, although I didn't realize at the time that it had such a meaning for him.

JS: Did his response surprise you?

Soleri: Well, he was trying to keep around himself a nucleus of the best young architects, building strong relationships so that he could have very good help with his architectural career. They would do much of the work. It was very reasonable for him to be upset. I think that was the first, and possibly the main, problem. Then, some years later it came to me that it might have been this business of the bridge. There was in development a book about bridges by one of the senior fellows; she was a writer. So Wright put together this bridge project, and then the author asked if I wanted to draw a bridge. I sketched one and it was in the same book. Maybe that irritated him.

JS: Why?

Soleri: Well, a young foreigner coming in and being put on the same level, in a sense, with a great master — he may have felt that was presumptuous.

Then there was an incident when Wright left Taliesin West for Wisconsin. Four of us were there working together in the hot desert, finishing one of the houses for the senior students. There was this rickety car at our disposal, a Model T that was our only means to move around.

25

Four or five of us, we would take junkets over the weekends. Mrs. Wright's sister and her husband were bothered by this, especially by our longer trips, and whatever disturbed them disturbed the family, especially Mrs. Wright.

Another thing that apparently upset things was my asking coworkers to start work at four in the morning instead of seven so we could avoid the midday heat. That wasn't received very well. And the last thing was probably my wearing of bikinis — only bikinis and, when I was outside, sandals. I think that was the last straw. Mrs. Wright was very conservative in that sense.

JS: How were you invited to leave?

Soleri: I received a letter in the mail from Mr. Wright, because he and the family and the fellowship were still in Wisconsin. The invitation was brusque and not very kind, but it really didn't bother me too much. For the other three architects I was working with, it was really a trauma. They all left.

JS: It sounds like you were disturbing the chemistry.

Soleri: Well, yes. If I had been more sensitive I would have done things differently. This is a lesson I didn't learn until we built Arcosanti. I now realize how upsetting it can be when someone comes from the outside and insists on just doing things their own way.

KR: Do you have any idea what triggered your independence of mind even at that point in life?

Soleri: There was never an effort involved as far as I remember. It just came out. It was my way of going about things. The Italian Piedmont is known for its unmoving sorts of people, so some of that might be in my experience

In any case we left Taliesin, and Mark Mills and I moved to Camelback Mountain. It's in the center of Scottsdale now, but then it was pretty much an empty desert. Mark was a very nice fellow and we were able to communicate. He got in touch with this developer and they

agreed that we could put a tent on his land in exchange for some consulting.

JS: This was about the time of the Dome House project. How did that come about?

Soleri: Mrs. Wood was from Philadelphia; she had a sister living not far from Taliesin. After her divorce she decided she couldn't live permanently in the East and tried to settle here in the valley. Since she had visited Taliesin, she also had some kind of contact with Mr. Wright. So I think there was something going on — her trying to get some design from Mr. Wright. That didn't work out only because she didn't have any money. So, as usual, when you don't have any money, you come to me (*laughs*). So she came, and she came with her daughter, Colly, who later became my wife.

Mrs. Wood asked me about this idea of hers for a house with a bedroom from which you could look at the sky. I had just drawn a number of sketches which had been included in a published book and some of those sketches were of dome houses. She was impressed by them, so we agreed that we would move to Cave Creek — myself, Mark, my future mother-in-law and Colly — and build a house. It was very elementary and very small. It cost three thousand dollars to build, including our living expenses and materials and everything.

The Dome House had a core, which was the shower and the bathroom and the toilet, and then on the south side a kitchen, and above the kitchen a dome room. And then on the side of the core, there are what you might call two bedrooms. Very, very tiny. We put a rotating cupola around it so you could control the amount of sunshine that you get inside. We did that, but the technology wasn't good enough to be able to turn the dome very easily. When Mrs. Wood was presented with the notion of having to push the dome every other day or so, she felt she couldn't do it and so we just settled on enclosing the two halves and cementing the dome. That meant that the interaction with the sun and the occupant wasn't really that successful.

After completing the Dome House, Colly and I were married there,

in 1949. She and I traveled to Italy the following year. We were considering all possibilities — staying there or coming back. Colly, it turned out, liked very much the experience. It must have been traumatic, but she liked it. Torino was our first destination; we were there maybe two years, with my family. Then we were about to have a child, so at that point we decided we had to separate from them.

JS: Were you working as an architect during those two years?

Soleri: I was working mainly at finding a way into the market for graphic designs. When Christine, our first daughter, was born our family was now three persons. I suggested that we buy a truck and start traveling through Italy. There was a company in Milano that produced chassis and people would build what they wanted to from them. It was a very good make. Usually people would make a big pickup truck. We bought a new chassis, and it was delivered to me in Torino. Then I found a shed somewhere and welded it all together. We had electric light inside, a water tank on the roof, and in the back a sink and everything we needed to live.

JS: So that was the second home that you built?

Soleri: I guess it was. Now at this point I didn't really know what I wanted do. In Torino I had been mostly silk screening postcards and had made a little business of it. Colly was helping and she was enjoying it, but I thought maybe ceramics would be a good thing to learn. We left Torino and headed south. I don't remember if we knew anything about Vietri pottery; probably we knew something. We drove along the Tyrrhenean coast, through Rome and Naples and Sorrento, and eventually we reached Vietri sul Mare. As we approached the town, there were shops on both sides of the road where families had ceramic pieces hanging out for sale and workshops in the back. We decided to stay there for a while.

One of the families that we got to know in Vietri was the Solimenes. I would go to their workshop and help them a little while trying to de-

velop my own style of pottery. I did very little throwing on the wheel — some, but not very much. I mostly molded, working chalk clay into containers with a handle. I did some very elegant pieces. And I did many of those in black, which meant I put the rough clay of the object in a box of coal and then put the box in the kiln. The carbon fumes penetrate the clay and produce a very nice, shiny, black pottery.

Well, it turned out that the Solimene family wanted to do something bigger. Their business was flourishing, and they had a design done by a local civil engineer for a new factory. In carrying it out they cut away part of a hill, a big chunk, and made a platform on this very steep rock. But the design was a very poor design. They knew I was an architect, so they asked me if I could help.

KR: Where did the idea of using the actual materials of the factory — fragments of pottery — to build the exterior come from?

Soleri: Well, it came about very naturally. They produced pots. Why not use them in other ways? The Solimenes always liked the idea. I was sort of surprised and scared but they liked it.

JS: Did the success of this project steer you back towards a career as an architect?

Soleri: Yes, it started me thinking. In fact, I was surprised that it was so easy to enter the market and build a very sizable building and to do it very smoothly. We never had problems with the client or anything like that. That was due in part to the fact that we had a very good team. I worked with Italian colleagues who were very good: my sister's husband, who was an architect and an engineer, and a school friend. We were so meticulous.

JS: How long did the Vietri project take?

Soleri: About two years, in 1951 and 1952. Then Vietri had this catastrophic flood that destroyed part of the town. Everything along the shore of the river was demolished and, as things go in Italy, it took a

long time to get the town running again. Power wasn't there. You had to go long distances to get water. It was a disaster. The summer tourist season was also disrupted because the beach was a mess. So after many months of being in Vietri, my wife went back to Pittsburgh for the marriage of her sister. While she and our children were there, we decided that rather than having them come back, I would join them in the U.S. I came back here and we all moved to Santa Fe. I had some experience now in ceramics, so we rented a house with a little courtyard and started doing pots.

JS: Why Santa Fe?

Soleri: We liked Santa Fe. We knew that Phoenix was very hot. Santa Fe had a climate that was more appealing, and Santa Fe was a place where tradition was, where native and Mexican traditions were coming together with very good crafts and arts, and so on. Then came the fatal event that led me to making bells.

While we were in Santa Fe selling some of our pots, one or two shops turned to us and asked if we could supply them with bells. "We have been selling lots of bells, Korean wind bells," they told us. The GI guy that was making Korean wind bells for them — he had been in the Korean War — this guy had died months before. "Could you carry on the production of wind bells?" The last thing that came into my mind was to make wind bells. I didn't even know they existed, in a sense. That's why my first reaction was, "Well, I don't know what you're talking about." But then after a few days, a few weeks, I started doodling with this notion of bells, and I accepted. I started to make bells. They were not, in fact, Korean bells, but the shops carried them, and they started selling.

Very soon, however, after maybe five months, we realized that for our bell-making activity the climate of Santa Fe wasn't right. The process was handicapped by those freezing nights. We thought we should try somewhere else. So very soon we decided that we should maybe come back to the valley. We knew this area, the Phoenix area, so we hunted for a house here. The place we found, in Scottsdale, had been

built for a painter, one of the three well known early painters of Arizona, Lou Davis. Davis was a good painter and his wife was a potter. They had this house built for themselves, or they built it. Davis' studio is my bedroom now, and she was doing pottery. One funny thing is that the kiln she had used here had been purchased by somebody in Santa Fe and when Colly and I first moved to Santa Fe we bought that kiln — you know, coincidence — and we took the kiln back to the same little house in Scottsdale.

The house came with five acres. And then I started. The soil was so appealing in terms of texture, and homogeneity, and so on, that I started punching holes in the soil and casting little objects, including little bells. This is a very old technique called slip casting. You take very liquid clay. You make an impression into a medium such as silt or soil or sand and pour the clay into it. The medium absorbs moisture and leaves behind a thick coating of clay. Within about an hour, because the air is so hot and dry here, you can suck the clay that is still liquid out or pour it out and within another hour, two hours, you can pull the bell out. You pull the clay out of the impression and let it dry. Very elementary. That's basic slip casting. It's the method I began to perfect for making pots and bells and it's still used at Cosanti and at Arcosanti for making ceramic bells.

JS: Apparently you were getting a very sound knowledge of materials, of earth.

Soleri: Yes, at a very elementary level. So then it came to my mind that maybe I could use the same technique in casting concrete. This was not a new idea because casting on sand, for instance, has been done before. The Romans had created forms by piling up whatever local material was available — sand, gravel, clay, soil — and then built structures with concrete or stone, or whatever. I didn't invent it. But I did perhaps do some new things with, number one, the relationship of the shape and the use of the form, and number two, in applying materials like pigments or plastics to get different textures, and so on.

The first earth cast building we did was one we call the Earth House,

at Cosanti. It's thirty by thirty feet. I piled up gently a little pile of earth from the desert, and then I shaped it. I cut some grooves in it and little patterns around the grooves. Then I put up an armature of steel — you have to be careful not to have the steel touching the form — and then I poured the concrete. After about a week I gathered some friends and we started excavating the earth out from underneath. All the grooves and designs and patterns came through. It was a wonderful experience to do that for the first time.

JS: And so the history of Cosanti as a village begins with this building, and then you began to build more.

Soleri: Yes. Some interest developed about the earth-casting technique. Friends of ours here got interested enough to bring students from the university and other local people to come and help in the pouring and so on. We carried on with this way of building, with our bell-making, and we started having workshops.

JS: Was Cosanti ever conceived of as a kind of community, an intentional community?

Soleri: Yes, eventually we formed a connection with the Taliesin mode, this notion that we would have a family and then surround ourselves with young apprentices of some sort. But it wasn't a commune, ever. It wasn't a kibbutz. It wasn't a resort, an air conditioned resort. It combined basic living space with working space, a garden, a pool. Thirty or forty people would join us in the summer and we would scramble to find room for them. We would rent ten rooms in the old motels around Scottsdale, and some apprentices would camp at Cosanti. The apprentices would work on whatever I was preparing, mostly building spaces for drafting, or for exhibitions, or for housing.

JS: What do you suppose attracted you to working with concrete?

Soleri: I just had a sympathy for concrete. I developed this sympathy mainly, I suppose, because what I admired in LeCorbusier was concrete work. Then when I found out this way of using the soil or the silt

to make so many different forms and ornamentation — that was pretty exciting. So over time I developed certain skills: the dosages, for instance, of moisture in the soil so the cement doesn't crack, and the timing of everything — finishing the form and casting it so that if rain comes, you don't lose everything. I also learned that when you have mastered a method or a technique for doing something, it gives you lots of freedom, so you have got to try to be disciplined. That lesson was partly the cultural imprint of my university training in Torino, and it has helped me a great deal, I think.

KR: How did you start working with bronze?

Soleri: It just came to my mind. It sat in my mind for a while, that I would like to try to do bronze as well as ceramics. Bells, I knew, were traditionally bronze products, so it was fitting. So we did a great deal of experimentation with bronze, using the silt that we had here to make patterns out of aluminum. We succeeded somehow, but it was still very amateurish. We would scrap around in Phoenix through junkyards for any kind of yellow metal we could find — copper, brass, bronze. I don't know how long that went on, and then we heard about this man from Hungary who was a foundry man.

We contacted him, and he agreed to come and teach us about bronze. We got a little more equipment — not very much, but enough to become almost semi-professional — and he showed us the tricks of the trade. And so we started producing bells in bronze. We were doing the entire process of bronze work at Cosanti, including the pouring, and we began to involve more people in the foundry because a market was developing. After a year or so, the Hungarian left with his son and set up a bell factory near Carefree, north of Phoenix. There was a direct competition because they were using our molds.

JS: Your molds?

Soleri: Well, yes. We tracked it down. There was a guy working with them who had worked with us, and he was using our designs to make his own bells. They ended up finding this guy dead in a mine shaft, I

33

think. I don't know where. But that was many years ago. And I didn't do it *(laughing)*.

JS: As more and more structures were built at Cosanti and more people were involved, did you learn anything about community life that influenced the design of the arcologies?

Soleri: Oh, probably by osmosis or something — not by design. My relevant experience in an urban context was in Torino. Cosanti was too small and too primitive in a way. And you cannot have an Urban Effect with twenty people. It just doesn't happen.

JS: Now this is when the Mesa City project begins.

Soleri: Yes. In the late 1950s I began doodling with urban questions. Nothing too serious, just fragments, and one day one of the salesmen who sold bells for us, a German, came by on one of his regular trips and I showed him some of the doodling. Toward the end of our conversation he said, "Why don't you design a city?" And I thought, "Why not do it?" I had experimented with the notion of cities in fragments. I thought, "Let's see if I can think in terms of the whole." It was another of those accidents, like the accident of finding the book about Frank Lloyd Wright, the accident of the factory in Vietri, the accident of the Korean wind bells. It was really an accident. That was the trigger.

So I came up with this idea about a city on a mesa. I really was taken by the feeling you have when you're out on a mesa, by the beauty of the landscape, by the fact that you have an open view of the lower land. I also had the notion that we should not colonize good agricultural land. To go down to good land like Phoenix and build a city there — You eliminate something potentially very good for the sake of something else. You should really put that something else somewhere else. Such an elementary notion.

But Mesa City, as it turned out, was too big. It was too flat. It was designed to hold a million people in a space about the size of Manhattan. The cliffs imposed limits on the city and wouldn't allow for the

spread of suburbs, but it was still a huge amount of space. As I was working out my ideas, making a few models, experimenting with how people would move, for instance, in this landscape, I found out that it would need transport systems — such as roads, utilities — which are fatally overwhelming. So I saw that something was screwed up there. At the same time, I had this insight, this eureka, about exploring the implications, in the design of a city, of complexity and miniaturization.

Take one human brain, for example. If it were two-dimensional it might cover an area of twenty or so square miles. There's so much going on within it that you would need thousands of miles of connectors for it to function. But the human brain, as it has evolved, is an example of enormous complexity which comes about because of its folding over, three-dimensionally, back upon itself, and the notion of miniaturization is intrinsic to this process.

So what I had been doing by spreading Mesa City across the landscape — and what we've been doing, in a way, in cities like Phoenix and Los Angeles, and most other places — is like taking the brain and saying, "Well, we want this brain to be more in touch with nature," and unfolding it across the land. By doing that, we destroy the brain and destroy nature — we destroy the city and destroy nature — automatically. So I realized that I had to keep things packed together, and see what that does in terms of the richness of life. I call that the Urban Effect.

JS: The Urban Effect, then, is the effect of miniaturizing our habitat.

Soleri: It's the impulse of reality towards organizing itself in such an intense, interlocked, interweaving, interacting set of elements that all of a sudden, it creates life and, perhaps, consciousness where before it was only mineral stuff.

JS: So, the Urban Effect doesn't only have to do with the city.

Soleri: That's right. It is something that from the beginning of life becomes a main presence. It pulls together, and then, by pulling together

generates a kind of overlapping so that you have might have, for example, closely woven layers of activity. It is an urge toward a condition that is more intense, and richer, and less segregated.

JS: In making this leap towards a more complex, three-dimensional city, who were your main influences?

Soleri: Reading Teilhard de Chardin was very important. I first read about him in *Time* magazine and then, in Paris, bought pretty much every book he had written and read them all. I don't remember how extensively, but I do know very well that one of his tenets is that life generates by way of complexification. In terms of applying this idea to the problems of habitat, I'm a loner.

JS: So the work on Mesa City evolved into the arcologies project.

Soleri: Well, yes, that came in kind of an avalanche. I like to work in a series, variations, so I started to do variations on this idea of a complex and miniaturized habitat, what I called an arcology, and I kept going. I filled up some papers, and then, from that material, we pulled out *Arcology: The City in the Image of Man,* the book that MIT published. The design of Arcosanti was the last sampling of the book.

JS: Can you talk a little bit about how Arcosanti went from a design on paper to a real place?

Soleri: We were continuing work at Cosanti, building through students' participation, and so on. I had Mesa City in the back of my mind, and then I started coming up with these arcology ideas. I began to think that the only way to implement something like that would be to make it real. So I started to look for land. On weekends, quite often, I would drive my little Fiat 600 around the Phoenix area, not further than about a hundred miles from Cosanti, so that we could have a connection. And one of the last properties I surveyed was the land where Arcosanti is now, about seventy miles north of Phoenix. I was surprised to find on this flattish, desert land that there was a canyon so beautiful, very green.

JS: Did you have a sense of how Arcosanti might look in that place?

Soleri: I already had drawings together for the MIT book so I must have had my eyes on this land. Arcosanti is the last project in the book. At this stage, I was trying to be very, very coordinated with the theme of three-dimensional habitat. If you look at the early model done of Arcosanti, you'll see that it was one building, really. But when it came down to start building, there was no way we could think of doing it that way, so I started working with substructures, and that's how we started.

JS: What was the problem with having one main structure?

Soleri: Finances. We didn't have any money. We were still paying for the land while generating lots of bills. I was pretty crazy to get this idea started. First we built the vault, then two appendages to it, which are residential. Then the ceramics apse, the craft gallery and café building. It was very exciting because we were very full of energy and people were coming to help — students and so on.

JS: What do you think your place was in the culture of the 'sixties. I have this impression that you were a figure in some of the social movements that were about during that period.

Soleri: Well, you must consider that I arrived in the U.S. and then I withdrew. I went to the desert. That's what happened. So my understanding of American society was very, very flimsy — mostly through some radio and television. If the 'sixties had an influence on me it was somehow negative. I should have known more about the political situation. I never had great enthusiasm for the rebels of that time because I feel that before you become a rebel, you should know. A young person doesn't know enough to be a legitimate rebel. As soon as the youth imposed their culture on society, I felt very uncomfortable. I tend to believe that growing up has a meaning, and growing up doesn't stop at fifteen or twenty. It carries on.

JS: You have described yourself as a young man as a hippie.

Soleri: Yes, but I was different, kind of. I wasn't conforming with a movement. There was never the notion in me that I could change the social nexus by wearing a beard.

JS: But wasn't it the young and revolutionary who were attracted to you and came and helped?

Soleri: Those who came, they came with a sympathy for our project. Some of them happened to follow hippie archetypes in a sense, but they were not, let's say, living an anarchic kind of free for all: "I'll do what I like, and don't bother me." There was a certain prohibition. Maybe my own behavior was such that it did not encourage this.

JS: Let's return to the subject of Arcosanti.

Soleri: I've been saying recently that there are two things that are apparent on this planet in terms of the presence of humanity, even from outer space. One is agriculture and the other is habitat. Those two domains are essential, and in any absence of them, we do not exist. If we cannot feed ourselves, evidently, we do not exist. If we cannot shelter ourselves it is the same; shelter is mandatory. It may be a cave, it may be a mansion. Whatever it is, it is a shelter. Habitat is one of the two key presences on this planet, and that's why it's so important to build it right.

So, when we started at Arcosanti, we had to build shelter for people that enabled them to do whatever people do, including what I call the culture institution. We had to shelter both the body and the mind. We started with a camp down in the canyon as a temporary shelter, then we came up to the top of the mesa and built the two residential spaces. We went on from there.

JS: In starting Arcosanti, did you learn anything surprising about people's needs?

Soleri: I originally conceived of the daily cycle as partly public and partly private. Taliesin West tended to encourage that. Taliesin was a place where you live and work, and you eat, and you connect to other people, which means that some things were made communal. When we came

here, the idea was that we would have a number of separate living spaces, and then prepare and serve meals at communal places. But it turned out that that's very, very difficult to do. Unless, you have very strong, self-responsible people, you've got a mess. If someone is not willing voluntarily to wash the things in the sink, for instance, in a few weeks the sink becomes a garbage can. So it's very difficult, especially with children who have not been injected, culturally, with the notion of self-responsibility, or with children that rebel against self-responsibility.

We originally had communal kitchens all over the place, but as Arcosanti has evolved, some of them are working, some are idle. There are still kitchens catering to maybe three, or four, or five rooms. In some cases, they work fairly well, but they are almost an appendix to the café. So this is something we had to learn by experience: how difficult it is for people to be responsible in a group activity.

There's the additional element that, for instance, you might have four or five people working very well together. Then a new person comes in, or one of them leaves, and it disrupts the harmony of the group. When you add the sexual element to it . . . Young people, you know. So it's very difficult. I've learned to admire in many ways the old culture where things seem to be working. I think of the French. They're libertines. They do all sorts of things. But they seem to be definitely surviving and doing quite well.

JS: How much of that behavior is a result of American culture?

Soleri: American culture is really the most dynamic in many ways, and the youngest in many ways, the one with the least historical background. So there's a great freedom of growing in any direction. Unfortunately, there isn't what some sense is the experience, the historical experience that makes the French person, or English, or Spanish, or Italian. And I guess, that's the price of being young. Not only as a person, but as a culture.

JS: Are there moments in the evolution of Arcosanti that stand out in your mind?

Soleri: Arcosanti grew much faster in the beginning, which is paradoxical *per se* because we had less money than we have now. It was pretty dynamic in that period. Interest was developing, not locally, but it was developing, and we began to attract foreign students. Among them were many Japanese — we still have a strong connection there. I think we became better known in foreign countries than in Scottsdale or even here in Cordes Junction.

Another thing that developed at Arcosanti were arts events, so that it would have some kind of a cultural identity. I insisted on that. We had two very effective, very successful large music festivals. We had as many as three thousand people down here at the amphitheater and many of the performers were quite well known.

I guess we did achieve some local fame during an appearance by Richie Havens. He was performing down in the amphitheater when we saw this black cloud, this black cloud rising from the mesa, and it was a strange one. I didn't know who would be doing that. And so we went around and up the hill and it took only a few minutes to find out that 128 automobiles were burning in the parking lot. It was grassland there and there were more cars than we were expecting. One explanation was that somebody saw this guy smoking among the automobiles and that was the trigger. Probably the best idea was that some of the cars were hot, so the grass, the engine... We made the national news.

That was the end of the more ambitious music festivals. At that point we started to produce more modest events, which we're still doing. We host between six and eight musical afternoons or evenings through the year, mostly classical music, but also jazz and dance. And then we have people come who want to do something on the spot.

JS: Any other noteworthy events?

Soleri: Well, there were the Minds for History conferences, we had a sequence of those. We would invite very bright persons and they would meet for an afternoon, for instance, in our theater here and interview one another. Harvey Cox from Harvard Divinity School was a guest, Stephen Jay Gould — we had at least three Nobel winners here. My

idea was to find out what kind of model of reality they would have. I found out that great minds often don't care too much about reality.

Perhaps Frugal Soup is of some interest, too. It is the only ritual we have here, which is not even a ritual. We have what we call Frugal Soup once a month. When we have a new group of students, we meet on a Friday. We go outside or we go somewhere and we serve a simple soup and that's the lunch. It's connected with the fact of famine, and malnutrition, and poverty, and so on. The first cup of soup is in silence. The second cup of soup, people can come out with comments or readings, or whatever they might be moved to say. We end up by having all sorts of reactions. So that's the only ritual that we do. But we don't require anybody to participate.

KR: Why do you say that it is not a ritual?

Soleri: I grew up in a Catholic family; not that it was strict Catholic, but I always went to Mass every Sunday, my mother went to Mass daily. My father liked the sound of sacred music so he came to church for that. So I grew up with this pleasant notion about rituals. I enjoyed them a lot, enormously. But then I recall seeing as a child a male initiation ritual on television, in Indonesia I think. I began to understand that rituals could be scary, very scary. Rituals became something I really feared. I like their pageantry, but I'm very skeptical about the content.

JS: Let's talk about the idea of frugality and how that fits into the way arcologies are put together. It seems that for you frugality doesn't need to be articulated; that frugality is simply part of your personal make-up.

Soleri: Well, yes. In my case it may be genetic. It may be cultural. My family was never affluent. But I see frugality as certainly something greater than that. The opposite of frugality, I call that illness, illness not only for the individual, but for life in general.

In order to come out with a species, it takes an enormous amount of work, let's call it, with lots of waste, and lots of abortions, and so on. But once an organism is defined, then that living organism, every liv-

41

ing organism, is a model of frugality, of leanness. Even a glutton is frugal if you really look him in his totality. With relatively few pounds of matter he goes through a life of fifty or sixty years, which is quite exemplary of the frugality of life doing incredible things.

KR: In your notes you talk about something you call, "the Love Project." Could you say a few words about that.

Soleri: Humanity, I would suggest, is the front runner of evolution. We're the most advanced form of life on this planet and thus we have a responsibility. If it's a meaningless reality we live in, it's our responsibility to give it meaning, to inject meaning into it. I call this "the Love Project." It's our invention. We invent love, generosity, compassion, charity — notions that you don't find in nature. You don't find them among animals, although you might see some traces of it. So it's our task to inject meaningfulness in the meaninglessness, it's a battle against indifference.

Naturally, these are anthropocentric notions, but we cannot get away from it. We are anthropos, we might as well face it. That's our interpretation of things. My hypothesis is that if the universe is open, and goes on endlessly, we might as well be resigned. We would be just an insignificant phenomenon. We might as well forget about eternal life or the persistence of our presence, and so on. But if, on the other hand, the universe seems to be a closed cycle, proceeding towards some end point, then one could say, "Why don't we think in terms of transforming the whole of the cosmos into mind, into total knowledge." Total knowledge of what? Of itself. If that were to happen, then it follows that everything that has partaken of this creation must enjoy it.

JS: Because if there were elements of this totality that were suffering, or that were subject to other parts of it, it would be a dysfunction?

Soleri: Yes. And not only that, an inequity. In order to have a truly equitable condition, you have to have a kind of condition where all the parts of the whole partake of the fulfillment of the whole. That state can't be achieved as long as inequities within the system continue.

JS: You're suggesting that if you have an inequity, that inequity entails a subject and an object. And what you're transcending toward is a complete subjectivity.

Soleri: Yes, you identify with everything else. Everything has internalized.

JS: Are you describing a state of consciousness that an individual might be able to achieve in their own lifetime outside of the whole of reality achieving it.

Soleri: That would be delusion. Because while I get into this condition, the child is suffering and dying and there's so much pain and suffering going on that my own resurrection, my resurrecting myself, would make me the chosen one, which represents an inequity. I see that as delusional, because the light toward which we might reach is not there. The light has to be created, and we are part of this creational process for the light. The light is slowly being generated. By what? By consciousness.

KR: So it is not something that exists out there to be attained.

Soleri: No. There is no mandate. There is no one telling you, "You shall do this and you shall not do that," and so on. We create our conditions in darkness. And the darkness is with us until the possible final moment when the light has been created. The beauty would be that, at the end, you find out that you as a means have become the end, because you are an integral part of the end. We will, of course, all of us, die before getting there. But we belong to something greater that is trying to get there by way of our efforts.

JS: How does cyberspace fit into this hypothesis?

Soleri: Cyberspace might come in some morning and say, "Sorry, nice people, but you're no longer needed. We'd like to put you in a museum," and the world becomes a nice museum. A zoo.

JS: And where does that fit on this progression towards total intelligence?

Soleri: Well, in my total ignorance, I'm saying maybe we should be aware that this is a possibility. So the question is, How can we organize this new baby that we are generating, cyberspace, so that within this new baby there might be an awareness of the greatness of the biological?

This newest organism has no past. Its beginning is when we invented the first computer, let's say. That is its history. Something that has no history cannot have compassion for what comes before because it doesn't mean anything to it. So this silicon or post-silicon intelligence might be totally indifferent to the plight of the carbon phenomenon which, after all, has been around for only four and a half billion years. It may be that a biosphere is totally unnecessary. There is no need there. So the whole flourishing of what we call the biosphere becomes extinct.

JS: Do any of these ideas that we've just talked about translate into the design of arcologies?

Soleri: Yes, in terms of helping life as we know it move toward that end. But such an end does not come before three or four eons, so that's a pretty long trip to go.

JS: How do you see Arcosanti fitting into the environmental movement.

Soleri: Well, I'd like to be more acquainted with the environmental movement, which I'm not. One thing that has always irritated me is that there has been no hint in the environmental movement, as far as I know, about the connection between our presence in terms of habitat, and the environment. I have always said that the salvation of the environment is in the city. Should we ignore the city, forget it, the environment is going to be a shambles. By doing so we would adopt the most wasteful, the most polluting, the most fracturing, the most segregational kind of pattern. So the salvation of the biosphere as the environmental movement wants should be geared to the presence of the city. This connection has never been made.

I go back to the view from outer space: you see agriculture and

habitat. Those are massive interventions on the biosphere. We are going to be very destructive in the biosphere if those interventions are incoherent. It should be self-evident that the suburban and exurban expansion of cities as we have now, with their demands in terms of production and consumption, are destructive of the environment. The bigger my house is, the more I'm going to stuff things into it. And the bigger my house is, the more isolated my house is going to be from the next house. It's very elementary. So the logistics of human connection should not be just connecting mentally or socially, but connecting physically, connecting physical needs — groceries, utilities, garbage, water, sewers. We should perhaps, as environmentalists, accept the very notion that we have a need to congregate.

JS: So, in a sense, you protect the natural environment by centering attention on the cities, while the work of many environmentalists does the same by focusing efforts on the wilderness. Surely there's a meeting point there; there's not a conflict.

Soleri: Probably not. The urban condition responds to the nonurban by saying, "I'm going to limit myself. I'm not going to invade the domain of nature. I'm going to contain myself, and develop what humans seem to be interested in — culture, knowledge, all the human things." So, it's not indifferent to the environment. It's exactly the opposite, in a way. I'm saying that if we start to build houses outside the urban condition, then eventually nature is gone. In order not to do that, we have to contain ourselves. And my hypothesis is that we will find that containing so positive, so rich with intensity that that's the answer.

JS: What role does Capitalism play in shaping cities?

Soleri: I have never experienced Capitalism, in the sense that my main interest has never been to control things by way of ownership — by way of a political or economic circle that makes me powerful. That wasn't my interest, and it's not my interest. So my personal experience in terms of Capitalism is almost a zero. But I naturally recognize that Capitalism

is a fantastically powerful machine energy. It can produce fantastic results and also the access to things that are not available without capitalists. So Capitalism, I think, is a good example of how we can take advantage of what reality might be and make it work for us, not just individually but as a group in better ways. But since we are fundamentally self-centered and opportunistic animals — not as a population, but individually — the danger is that we neglect essential measures. The accumulation of wealth most of the time is corruption. Money corrupts. It's so self-evident everywhere.

JS: You have an ambivalence about Capitalism.

Soleri: Yes. Unless we inject compassion into Capitalism, Capitalism is going to be a curse.

JS: When you think about an arcology, how does the distribution of wealth come into that?

Soleri: That's when I bring out my instrument analogy. You can have the best violin and have a terrible sound coming from it because of the player or the composer. The instrument *per se*, which is what I am designing, doesn't define the quality of the music.

But to answer your question: I suggest that we realize the necessity of invoking a process towards equity. I think that's true because in my model, reality is not benevolent. It is indifferent. Indifference is the resource we have, so we have to work with it. Now we have done miraculous things, but we are so young, so unknowing, and so opportunistic, that it's going to be a long, long, long battle. It has to be a battle. And the arcology is perhaps a useful instrument in this battle.

KR: Isn't there an inconsistency here? If reality is indifferent, wouldn't you expect our evolution to shape us to be similarly indifferent.

Soleri: Okay. Well, I see that as the true miraculous nature of what we are. If there were a benevolent reality, then we would be just little tiny creatures that attempt in a very unfitting and very unsuccessful way to

recapture this harmony, this benevolence. That's a way of being I don't want to have anything to do with. I believe we live in a very powerful, very harsh, and very indifferent reality. And if we can begin to work into it, and work into it by way of compassion, of generosity — all those things we invent — that's our greatness. The answer to indifference is to penetrate this universe and transform it, transfigure it, in a way, in the image of ourselves, to improve our image, and at the same time dig into reality.

JS: Still, one might ask, "What's in it for us?" What would motivate us to evolve in the direction you suggest?

Soleri: This is my model: that the only way we can validate our presence is to believe that we might eventually resurrect. Nothing Christian to it. We might be somehow present when the glorious ascent might come about. The glorious ascent for me is that the whole of reality should become triumphantly self-aware. Theology — I use the term "animism" — is an obstacle to this. Perhaps we are wasting our best energies in trying to get in touch with our creator. The sad thing is that, as far as I know, the creator is not there. We are self-creating.

JS: If your vision of the urban ideal were to be realized, or even approximated, could it happen in cities that are already there? Could it happen in Phoenix, for example, or do you have to start fresh?

Soleri: Well, students of mine have been working on this — to see what the existing patterns are and try to improve them. My disagreement with them is a skepticism, a sadness. I have my slogan which applies here: "A better kind of wrongness." When you try to improve wrongness, what you do is you make it wronger. You make wrongness successful. I always use the gun example. The original gun was a little pipe that projected lead or rocks or something. Now we have guns shooting three hundred bullets a minute. That's a consequence of a constant improvement of what I call the wrong thing.

Consider also Frank Lloyd Wright's Broadacre City. By perfecting

the notion of the suburb he helped glamorize it, legitimize it. That was, for me, another typical case of something wrong getting wronger through the elaboration of very intelligent and very clever and very good design. It was never built but, in a sense, it's all over the place now. So here we are smack in the center of wrongness.

JS: Would you argue that if we were successful at bringing people into arcologies, that there might be a kind of acceleration of human evolution, an expansion of, say, creativity or imagination or consciousness?

Soleri: Yes. One could say the same thing about London or Paris or Hong Kong. They have unique identities that not only define the cultural means of those places, but that also impact the whole of humanity by the fact that they exist. People know they exist and they like to at least gain an impression of them. They have to travel to them. This is a consequence of a dynamic that doesn't exist in individuality.

JS: Nor in the suburb.

Soleri: Nor in the suburbs. The critical masses don't develop there. Without a critical mass, you don't have fire, you don't have energy, you don't have thinking. I mean in terms of quantities, I mean proportionally. Consider the institutions that we've established: the secondary school, the university, the medical center, the theaters and concert halls. Those institutions become almost automatic when we have this critical mass of individuals, and without such a critical mass they could not exist, in part because we could not afford them. That's why the city is a magnet.

JS: In an arcology, how do you foresee meeting the expense of these kinds of resources?

Soleri: I am building a laboratory; I can answer this question only after the instrument has come to form. At that point I could suggest an estimate of the cost, but it would have to be a hundred years estimate, because the investment, the original starting investment would be much greater than developing a tract city. We would have to invest not just in

the thirty-year mortgage, but in something that is far longer than this — two and a half generations or so. Then we could make a parallel between what the suburban costs and what the arcology costs. Remember that a suburb cannot support the desirable institutions. They try, but most of the time, they're thrown back to the city.

JS: Now might be a good time to talk about what you call second-generation arcologies. What do you mean by this term?

Soleri: Well, these are urban environments that are more aware of climate, of the sun, more receptive to using the heat of the sun. The first arcologies were sort of mental. At their base was a mental process — that's the radiance of the mind of people. At the base of the second generation is the radiance of the generator of life, which is the sun. It is present also in terms of the energy of natural light.

JS: How did the sun emerge as the source of a second wave rather than water, or topography, or transportation, or something else?

Soleri: Number one, we are children of the sun more than children of water. We are water, that's a fact, but the sun is what does it. It cleans the water by moving it through rain, and floods, and oceans, and rivers. The sun is the engine that does all those things. Number two, I think we tend to build our lives toward the light. And third, there's such a quantity of energy that pours down on top of everything — why not make use of some of it?

So to put it very, very crudely, the first sun arcology was two half sections, split apart and turned to face south, where you see this radiant presence. I have many volumes — ten volumes, four hundred pages each — of sketches related to the second generation. That's four thousand pages, and then I have butcher paper. Rolls of it. An architectural firm that does all sorts of things all over the globe has expressed interest in working with these drawings. These conversations have been going on now for many months, but I feel that it will go on for many years before we get anywhere. My idea is to present to them what I could call

the cleanest design, a skeleton that might hold 50,000 people, and present them with this as a laboratory. Let them work with it.

JS: What about the third generation arcologies?

Soleri: I'm not totally clear about what has been called the third generation. But I think you can use that title for my space drawings. This came about as a consequence of that great President — Mr. Star Wars. What's his name?

KR: Ronald Reagan.

Soleri: Yes, him. The point of Reagan's Star Wars was that not only are we going to dominate the planet, but we're also going into space to take care of the Communists or whatever. I found this very entertaining if not stupid. So I started doodling and I came out with some diagrams of arcologies in space, arcologies that represent a peaceful detachment of humanity. This was Space for Peace. It was in response to Reagan.

The specific detail of moving habitats into space is not just a highly technological feat, but also a highly cultural feat. After the first phase, which is going to be highly technological and almost totally dedicated to technology — the technology of surviving — there will be a second development where a population could migrate or a population could be born into a space environment. So I started thinking maybe that environment could be similar to a minute arcology. My suggestion was that capturing an asteroid might be one of the steps. This suggestion has not only come from me; others have proposed that a presence in space could be done in that way. The asteroid would be mined, excavated and transformed so that after a certain point you generate an ecological bubble that would be very elementary, very primitive, very limited.

In this city in a bubble, this ecominutia, as I have referred to it, I see not so much our children going there, but instead our eggs and sperms going there, who will generate life there from scratch. Or perhaps, instead, it would be artificial intelligence going there — a post-city kind of colonizing intelligence.

JS: Would this be a solution to problems of the planet, or is it an evolutionary necessity we're being pulled towards?

Soleri: I don't suggest that we take ten millions of people or a hundred millions of people and shift them out there because of demographic pressure. But space would be a good place, for instance, to build a laboratory. It would also be a good place to start to think in terms of whether we are worthy of the universe. To limit intellection to Earth, this very, very tiny, almost invisible speck of reality, is silly. You cannot consider that forever. So the expansion of self-consciousness throughout the universe might be a service we want to offer to ourselves and to the universe.

KR: Twenty years ago you used the word "spirit" in your writings as central to understanding humanity's purpose. Now it seems out of place. What happened? What has changed?

Soleri: What happened was that slowly I got very incensed at what I call theology because I felt it was so damaging to individuals, and to groups, and to society, and to nations. In my hypothesis, theology raises a fraudulent notion. If God doesn't exist, and we give so much in satisfying God, satisfying a lie, a nonpresence, a nonexistence — well, that's pretty sad and pretty traumatic. Why should we? We should try to deal with reality. Not with notions, with delusional notions. And not only is theology distracting, theology is destructive. We've been killing each other for theological reasons from the very beginning of consciousness. So it's demonstrable that the theological system has been cruel beyond compare.

At some point, I arrived at the notion that maybe to have a very, very simple origin was the best. So you start very, very elementary and you end up highly complex, from matter, or from meaninglessness, slowly you reach up to meaningfulness, and we are, each of us, very responsible for this escalation of meaningfulness. But it's not because we have an order from up there or are intimidated from up there, or because we are told that some entity up there loves us, and so on and so

on. It's the bootstrap process rather than the mandate process. That's the incredible beauty of it, you know. We, ourselves, create whatever is graceful and God-like. Life creates it. Without him, without it, life is the force that creates it. This hypothesis, I feel, has some merit, and so I am investigating it.

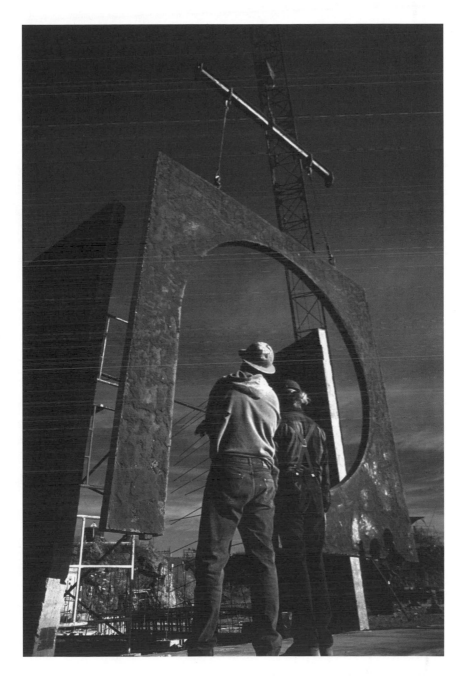

Construction at Arcosanti

The Evolution of the City

"Unless we moderate, unless we re-invent the American Dream, then it's not going to be a dream. It's going to be doomsday. Because the planet, for the first time in the history of mankind, appears as one of the main actors in the play."

This conversation was recorded in December 1995 at the home of former California Governor Jerry Brown in Oakland, California. It was broadcast on Brown's radio program, "We The People," and subsequently published in his book *Dialogues*.

* * * *

A native of Turin, Italy, Paolo Soleri came to the United States shortly after the Second World War to study with Frank Lloyd Wright. An architect, author and pioneer of new human spaces, Soleri founded the urban research laboratory, the Cosanti Foundation, in Scottsdale, Arizona, and, in 1970, began construction of Arcosanti, an experimental community in the high desert outside Cordes Junction, Arizona. Covering twenty-five acres in the center of a 4,000 acre land preserve and designed to accommodate 7,000 residents, Arcosanti embodies the principles of "Arcology," a combination of architecture and ecology, that Soleri has continued to develop throughout his life.

Soleri is the author of ten books, including *Arcosanti: An Urban Laboratory, Arcology: The City in the Image of Man,* and *The Omega Seed: An Eschatological Hypothesis.* I first met him many years ago when he visited California, and later traveled to Arcosanti to spend time with him. In this conversation, which took place in December 1995, Paolo articulated many of the factors that have shaped the design of Arcosanti, and can help to shape livable cities of the future.

JB: Paolo, let's start with some of the ideas which inspired the building of Arcosanti.

Soleri: We have been attempting for the last thirty years to introduce society to an old idea, the idea of overseeing the gathering of humanity into towns, cities and metropolitan systems. It is a very old story, in fact the Latin word for city, *civis*, is the root of the word, civilization. The term itself indicates that there's no separation between the appearance of cities and the development of civilization.

JB: So the city creates civilization. And yet there seems to be a destructive element along with it. It seems like the city, at least in modern times, in so many places, is very hostile to civilization, if by civilization we mean something that's elegant and creative and beautiful and pleasurable.

Soleri: Well, that has somehow become the pathology of the city. But every phenomenon has some pathologies, so we should be careful to discriminate between what the city can offer and has offered for millennia, and what we are now making the city into, which is, as you are saying, an environment which is not very conducive to good society. The fact is that if we eliminate all the cities from this continent, what remains is not much. Even though we Americans tend to be very skeptical about the city, we must recognize that the city is still the place where things are happening in scale and in quality.

JB: It's interesting that things are happening there in scale and quality, and yet cities receive such a low estimation, not only by people in government, but by people who are moving away from cities, and have been doing so for almost thirty years.

Soleri: That's a horrendous mistake. Let me give you a glimpse of why. We know that the population of the globe is doubling from five billion people a few years ago to ten billion by the year 2050. Whatever stress we put upon the planet now will double by the doubling of the population. So we will need the equivalent of two planets by the year 2050.

Then, we Americans have the American Dream to implement. Well, if we implement the American Dream and then make the American Dream a planetary dream — which would be very much in tune with the notion of democracy, justice, equality, and so on — then we must multiply the number of planets we need. Americans consume twenty times more than the average person on the planet. So if the American Dream becomes the Planetary Dream, and we double the population, we will be in need of forty planets by the year 2050.

JB: So we as Americans are modeling a way of life that will either require forty planets, or we will need to reduce our standard of living by forty.

Soleri: This is the sore point. Unless we moderate, unless we re-invent the American Dream, then it's not going to be a dream. It's going to be doomsday. Because the planet, for the first time in the history of mankind, appears as one of the main actors in the play. Its limitations are now becoming evident and we cannot ignore the very clear and very substantial fact that we cannot demand from the planet whatever we please. So we need to take the American Dream and frugalize it, to make it into something that instead of being geared to the ends of a materialistic Eden, becomes more oriented toward the inner life of individuals and societies. You might need less of the physical in order to produce more of the mental and the spiritual.

JB: We have to recognize that current patterns of affluent living, in America and the rest of the developed world, if not corrected, pose a real threat to the continuation of civilization.

Soleri: It seems to be really so.

JB: I think it's important just to pause a moment with that. The way we are, the way I drive my car, the way I live along with the other 265 million Americans — as we puff ourselves up as number one, we're validating a way of life that, when generalized in accordance with our own principles of democracy and equality, will result in the devastation of

the planet. Or, to look at it another way, we as Americans will require increasing numbers of people, billions of people, to live like serfs so that the planet can support our way of life.

Soleri: That's right. A privileged class of Americans and Europeans and whoever adopts their way of life would have to control resources and to, let's say, limit the fulfillment of the majority of the population of the globe. Think what's going to happen when China, India and Africa accept this cycle of hyperconsumption that we are championing. Things are going to precipitate very rapidly, and all that we are slowly developing is going to be catastrophic.

JB: All it takes is for China, India and Africa to copy middle-class American ways of being, and it's going to be a war for the dwindling resources available to sustain that hyperconsumerism.

Another difficulty is that now many countries, even China and India, have nuclear weapons and transcontinental missiles. Someone in India might say, "Wait a minute, we don't want to live on two hundred kilograms of grain a year. We want to live on four times that amount like you do. We have some nuclear missiles here, and either you start sending us grain or else. And let Vishnu take care of the rest."

Soleri: Yes, in a very short, concise statement that's a possibility. But now let me take this a little step further and bring in the aspect of planning and architecture. Why? Because of all the activities of mankind, the bulkiest, the most expensive, the most demanding, and the most necessary is sheltering. We have to shelter ourselves, our families, our society, and the institutions that society needs. So sheltering is really an immense imposition, an immense transformation of nature. Now, the most consuming, the most wasteful, the most polluted, the most segregating kind of shelter we can devise is the suburban home. So we are presented with a problem — we like the notion of expanding into suburban development, even though it's the most pernicious way of going about generating the future for our children.

JB: Okay, so that's another important point. It invalidates totally the discussion in the United States and Europe about expanding economic growth to bring suburban reality to many more billions of people. This is a distortion of what the human spirit is capable of.

Soleri: That sounds very, very harsh, but I'm afraid we have to read it for what it is. Since shelter is the most imposing activity in which we are involved, if our choice of habitat is the wrong choice, we are in for catastrophe.

JB: Are the suburbs wrong because they're spread out? Because they cover the soil? Because they kill other species? Are they wrong because they create shelters that have to be filled up with stuff that must be imported over great distances, and then someday disposed of, filling up even more space?

Soleri: All these reasons. Consider the single family home. The more financial power people have, the bigger their shelter, and the more they have to purchase in order to fill it. So we begin this process of building larger and larger units, isolating them into what you call the suburban sprawl, and then connecting each of them to the resources and the utilities and the retrieval systems like sewage and garbage and so on.

Those boxes are the epitome of consumption. So we have set up a cycle where we say happiness is consumption, therefore we have to consume more, which means we have to produce more, which means we have to transform more of the planet into what is connected to our own fulfillment, what is consumable. Orienting ourselves to that kind of materialism is going to kill us — number one, because of the limitations of the planet; number two, because it's an indication that instead of transcending toward mental and social excellence, we are embracing hedonism.

JB: Not to mention what being isolated and entertained in that box called the suburban house does to the spirit.

Soleri: Yes, because the more we surround ourselves with gadgetry that

we feel we need — and some of the gadgetry we do need — the more we tend to generate a condition where mental processes are not very interesting, not very necessary, and what becomes more necessary is to take pleasure in playing with gadgets and in other activities that are, in the end, not very fulfilling.

JB: And the less fulfilling they are, the more consumption we have to engage in to cover up the emptiness. It's almost like we've been cursed, so that our greatest skill is our ability to create the need for stuff that our second greatest skill, technology, can produce. And by reducing intimacy and friendship, we are forced to satisfy more and more inhuman and artificial needs.

Soleri: That's really what the consequences are. If a child is told from the moment he gets out of bed to the moment he gets into bed that the purchasing of an object is part of his or her own right and happiness, that child is going to be very faithful to this dogma. And so we end up having this notion that unless we partake in the market cycle, we aren't good Americans. The politicians tell us that; the corporate community tells us that; the theologians tell us that; academia tells us that. So we are really leading some kind of a utopian dream that is very dangerous.

JB: That's very interesting — even the religions. Christianity defines distributive justice as Thomas Aquinas talked about it five hundred years ago, but now it is being applied to a totally different world. We are surrounded by all these physical elements — these toys, these gadgets, the stuff — and if it isn't divided around equally, that's morally wrong. So the theologian argues for an equal distribution of stuff that's not needed, and which, when obtained, will destroy the basis for human community and religion.

Soleri: If you will think for a moment about what a shopping center presents us with, really try to penetrate the superficial impressions, and then consider the response to this of an Indian or a Chinese person for whom it is an incredible place of fantasy, then you begin to wonder where we are wandering with our minds.

JB: I remember when I was growing up. I was born in 1938, and I was probably six or seven when I went to a department store in downtown San Francisco for the first time. It was around Christmas time, and the top floor of the Emporium was a toy land. It was so exciting! I mean, I can't describe the rush that I had going there. But it was just a toy land during Christmas. Now it's Christmas every day!

Soleri: Yes, the exception makes for excitement, and now it's becoming almost boring. The little child with a mother that cannot afford even to make a living — the child goes into the department store, into the shopping center, and he asks the mother to buy this, and this, and this, and the mother has to say, "Yes, I will do my best in order to satisfy you." If she cannot satisfy the child, the child is a second-class citizen, evidently not worthy of the American Dream.

JB: Now, you have been grappling with this for a long, long time.

Soleri: I am seventy-six, but it doesn't take many decades to see that we are presented with a population explosion and with this demand for material fulfillment, and thus with a very limited future, and possibly a very bloody one.

JB: This is the dark side. What's the other side? What's the vision of the city that doesn't fall into this abyss, but starts things on a different basis? It was human evolution that brought us to where we are, but the purpose of the creation of the human mind can't be to fall into this trap. I don't think God would have put this kind of a hex on us.

Soleri: We can write a future history that shows other ways of fulfillment, and this might be a history of cities. They might tend to be very large, because through numbers we are able to afford things that are otherwise too expensive. At the same time the city presents an environment that is more frugal. Think again to the houses. Instead of having a large suburban house, I might have a very small urban unit, and I cannot fill that unit with as many things as I can fill the big house. So we have to see if we can adjust our mindset in such a way that we recog-

nize that excellence and worthiness are not measured by ownership.

JB: I recall my first visit to Japan, in 1960. My room was very small with a futon that rolled up. I would use the same room for eating, or reading, or sleeping, or whatever. Now we've taught Japan that they are doing something wrong. They're exporting stuff rather than creating domestic demand, and actually, in trade discussions between the United States and Japan, the assertion is made that the Japanese are hurting world trade because they're not consuming enough. So what you've just described as a virtue has already been defined as a vice in the western economic system.

Soleri: That indicates a kind of utopian economic thinking. It means doomsday because of the limitations of the planet. What in the past could have been promoted as pleasure is now a real menace because of this contest between the number of people, the consumption that we feel is imperative, and the planet's inability to deliver. And then overlaying that are the values and virtues of the human species, which might, in fact, be far more profound than materialism, hedonism, and so on.

JB: Since the human species can't go down the same road it's on, then there must be built into our structure some other vision, some other way of being. It can't be that what we need is what destroys us.

Soleri: I think this other way of being is interiorization, to make reality more and more an inner reality, where ideas are filtered by our minds and made very, very fulfilling. I will try to put it in more plain words.

Whenever we are in the presence of life, at any level, from the bacterial to the human, we are in the presence of a process that interiorizes matter and transforms it into life, and then eventually into consciousness, and then superconsciousness. This is what any biological system is driven to by its own interior motivation. Any technological system, on the other hand, has to be ruled and regulated by external drives.

JB: So life has some sort of inner principle that pushes it in certain directions, while technologies have to be pushed by outside purposes and plans.

Soleri: That's right. Life moves by an interior drive, which you might also call genetic or instinctual knowledge. With the appearance of the human mind, it also becomes cultural, which means this inner motivation is driven not only by the biological aspect of the individual human system, but also by the cultural aspect of the human community; but it is always coming mentally, from a decision from inside the organism. It's not coming from outside.

JB: So if what's driving us is coming from within, then what is without shouldn't be able to determine our way of being.

Soleri: What is without evidently is the reality in which we are immersed, so we cannot ignore it, but we might be able to guide it. And the best guidance is not to say, "Well, I'm going to gulp more and more matter in order to find my own fulfillment." We are now called upon to transform the exterior world in ways which are going to give more fulfillment in terms of our inner drives, ways which encourage our movement toward values which are generating from within us.

JB: It's almost as though our suburban materialistic expansion is like the paganism of the ancient world, which was overthrown by a new interior religion called Christianity. But the paganism here is so predominant that even religious groups are caught up in it and have adopted the materialism that they profess to be overcoming.

Soleri: And it's becoming more critical because now, as you were saying, we can arm ourselves with weapons which are really catastrophic. Our power to impose our wills is becoming greater and greater, and that which before was the ability of the despot to impose upon society, now is transferred to everybody. We are each in a way despots and want to impose what we feel is our right, ignoring that the right should always come with duty and responsibility. So by generating the conditions where we say we are free agents and we do what we please, we are transforming the singularity of a despot into a majority which says, "Yes, I was conceived, I was born, and now I do what I like to do. Period."

JB: Do you think the custodians of today's paganism, today's materialism, will treat those who oppose them any more kindly than the Romans treated the Christians in the Coliseum?

Soleri: Well, when things get very tight and the options become very limited, then the violence that we carry within ourselves could explode. I do not believe in the goodness of reality, in a benevolent cosmos. I try to gear my ideas to the notion that hardness and cruelty and suffering are very attractive and are ready to take over anytime. That is why I think that the future could be very bleak. Once the resources are limited, if our mental and moral resources become shallower and shallower, that's when something horrendous might be triggered.

JB: I spoke recently with Gar Alperovitz, the author of *The Decision to Use the Atomic Bomb*. And I'm thinking here that if democracies can drop a bomb with such insensitivity, and, even fifty years later, can't acknowledge the inhumanity of the act, what would the so called bad people, the tyrants, do?

Soleri: It might help to try to understand where we come from. And I don't mean that in terms of just your own experience, but the human experience. We come from three and a half billion years of exercising the life drive, and this exercise up to now has been opportunistic. Any kind of species works at being able to survive and to multiply, and in order to do that, the driving force is to find the most opportune ways of doing things. It has always been a question of opportunism in terms of population and species.

We have transferred a portion of this opportunism from the population or the species to the individual. We have invented something that we now carry in our blood and in our bones. It's a glorious invention. It's love, compassion, generosity, and so on. So we have to try to combine the opportunistic drive, the ego-center mode that increased our species, with this new invention, which is the loving, the generous, the compassionate. The kind of Social Darwinism that seems to impregnate Capitalism needs to be injected with a compassion imperative. And

if we are not able to do this, I am afraid that we are in for terrible troubles.

JB: And there you have a problem — that the organisms of Capitalism, corporations, reduce human beings to units of that one variable called "return on investment," denying their opportunism and their compassion.

Soleri: Perhaps I am more optimistic than you seem to be in this. I really believe that we are beginning to realize that this pure drive that says, "I'm the most intelligent, the most cunning, the most able, so I'm going to dominate," this drive is now seen as in need of an added dimension — the loving dimension. We should recognize that greed is ingrained, it's part of our make-up, because of this opportunistic drive that we have. But we have the ability to re-orient our greed, to make it into a desire which relates to the family of man, and to the family of all life.

JB: Greed has to be collectivized, has to be communalized.

Soleri: Yes. We have to transcend our individualism. Life is a transcending process. That is how we evolved from the bacterial into the human.

JB: Let's focus now on the city of the future. Having talked about all this, I get a sense of the criteria for the new city. It certainly doesn't look like Oakland or Manhattan or Los Angeles.

Soleri: Perhaps it is not too different from the old examples of successful cities. There have been periods in European history, for instance, when cities were successful. They gave us the Renaissance and then developments from the Renaissance up to the present day. The fact that we are gregarious, we are political, we need each other, indicates that eventually, the city is going to be, as it has been in the past, the container of community.

Now, Phoenix, Arizona is a structure of about six hundred square miles. So it's gigantic, and like so many cities, it doesn't work very well. It's sluggish by necessity, because it's gigantic. It depends on logistical systems which are colossal, in fact futile. So just in physical terms, in

terms of gravity and thermodynamics, Phoenix negates what Phoenix would like to be, which is lively, intense, joyful and so on. What we need is to take Phoenix, and in a way, fold it over upon itself, make it three-dimensional, so that we miniaturize its landscape, and by doing that we eliminate all the problems of the gigantic. This is pure physics; this has nothing to do with metaphysics. This is the fact that time and space are very precious and we should use them in the best way we can.

JB: Okay, now as you fold Phoenix into a three-dimensional city, what's it going to look like?

Soleri: Well, perhaps we would subdivide Phoenix into, let's say, ten sections, and then begin to build properties that are no longer one or two floors, but that are many, many floors, maybe up to fifty, maybe more. This is very efficient, it's where frugality comes in, producing less pollution and less waste. Depending upon the population, each section might be a quarter of a mile square, that depends on the number of people and the technology you want to put in.

JB: Would everything people do be done within that building?

Soleri: I would tend to say, yes, if you want to achieve a great efficiency, but we don't have experience with that kind of architecture. That's why we need laboratories to investigate what that implies and slowly generate the logistics, the transportation, the necessary functions, that are going to be the answer to this problem of the gigantic and the wasteful.

JB: And the city would husband resources and create far less waste.

Soleri: Yes. And the resident is going to be a city and a country person, because he or she can walk out of their home and be in the heart of the city or in the presence of nature, which is now impossible in the cities we have developed. At one side of the doorstep there will be culture, and, at the other, nature, the condition of nature in the area.

JB: Okay, you have study, you have sleeping, you have intimacy, you have working and production, learning and play, celebration, ritual. Now

65

it sounds like people are going to be living a lot closer together than they are now.

Soleri: This goes back to the European experience. For instance, my personal experience was in Italy. I was living in what you might call an apartment; it wasn't the best apartment because we were not wealthy. But our living room was the city. I could walk down four or five stories and be in the middle of the city, which offered to me all the resources a city provides, including the theater, the library, the university, the hospital, the playground, and so on. And that was available to me as a pedestrian, not as a person who has to enter this magic machine, which is the automobile, and then drive myself to those places further and further away.

JB: What about the concern that this is like a bee hive? How is this city made to be elegant, and not monotonous.

Soleri: That brings in the skills, the intuition, the vision of the planner, or the planners. That is why we need urban laboratories. In chemistry, in physics, in technology, we have laboratories. The laboratory is where you develop an experiment, and then you take the experiment to the breaking point so that through this failure, you learn about the subject. Well, we should do the same thing with those urban problems which are the most complex, the most demanding.

JB: Is it your feeling that if we are ten billion human beings and in need of forty planets, that through appropriate urban design, human beings could evolve in a way that would allow us to keep transcending in the way you described earlier?

Soleri: You're asking me to be knowledgeable, to be wise, in everything, and I'm not. But I believe so, because the future city must be frugal and frugality is ultimately interiorization. To be frugal does not mean to find happiness without ideas and without the aesthetic. You do not renounce when you become frugal. You open yourself to the interior values that are fundamental to the human animal. So to be frugal is not a

necessity only, it's a necessity which almost automatically becomes a virtue.

JB: Paolo, I want to talk a little bit about your idea of the Omega Seed.

Soleri: Maybe we should start with the semantic. Why Omega? Omega is the last letter of the Greek alphabet, so it suggests some kind of a conclusion, an ultimate condition toward which we are developing. It's a sense that many theologians talk about — they talk about a conclusion. That's why the term Omega. And why Seed? Because any kind of seed, including the human seed, is a blueprint for what an organism is going to become through its internal direction of development.

Now one could imagine that there is a seed that has a universal scope, what you might call a universal seed, a cosmic entity which contains all the information about reality. This seed contains the information about everything that happens in the process of becoming, from the very beginning to the very end. There really isn't very much of the metaphysical in this idea, but there is a notion that information generates knowledge, and knowledge, ultimately, is self knowledge. This implies that the Omega Seed points at the end of things, and at self-revelation, with reality becoming more and more conscious of itself from the very beginning to the very end.

Now, I tend to believe that at the beginning, at the Big Bang, there wasn't a written law or creational act by a divinity, but there was a choice between existence and non-existence. It just happened that existence came about, and when existence came about, it began to change. So that's the movement from being into becoming, and the evolution of things into becoming reality. That becoming at the beginning had rules that were co-natural to the nature of being; these are what we call natural laws.

Now, when life comes about, there is a new entity, a new agency that comes about. We add a new layer of reality, a higher level of reality, which is the layer of mind. Here we have animals; animals are intelligent and opportunistic. And we have humans; humans are intelligent and opportunistic, and they are also mindful, which means that we move

into the realm of consciousness and superconsciousness, where we develop new laws by way of invention. We add new levels of reality, and it becomes very evident that opportunity is no longer sufficient. We need something that goes beyond opportunity, and we call it compassion, we call it love, we call it generosity, we call it altruism. That's what characterizes man among the animals, the animal kingdom.

JB: So, you are saying that love and compassion are the next essential evolving structures that have to be brought into being by humanity.

Soleri: And it exists now. But it's fragmentary, it's weak, it's fragile, because we are still driven by the opportunistic frame of reference, and naturally we depend on the physical, the deterministic. We come from eons of development, so within ourselves there are these forces which are very powerful, and the most powerful of them all is opportunism.

JB: That is incredible, if love is what we are evolving toward. Do you think that love and friendship can evolve through design of habitat?

Soleri: Yes. But we cannot go from zero to a hundred in one short week. We start from zero, one, two, three, and so on. A hundred years from now, we will not exist as we do now. We will be very different, so we must start now to realize the importance of cutting into the gigantic systems that we have been building. We must invest in laboratory work in urban questions, just as we do in other fields, such as medicine. We use ourselves as guinea pigs in order to carry medicine forward, and should do the same thing with the urban condition.

In order to get to that point we need to persuade our politicians and people in power that as things are developing now there is no way we can succeed. And more important than just the politicians, we are going to have to get this idea into our own minds and really deepen it and share it. And as we begin to understand it, it can become part of the philosophical base of where our country, and every country, might go.

The Architecture of Consciousness

"Beauty cannot be created through logical processes, through ratio-nalization, through justice, or any such instrument. It must come into being through its own special process of creation: aestheto-genesis. Matter has to be metamorphosed, through anguish, into the aesthetic, the spiritual."

The following interview was originally published in the December 1973 issue of the *Journal of the American Society of Church Architecture.* Here Soleri discusses not only themes which have been consistent through-out his career, but also ideas, particularly related to spirituality, that he has subtly but pointedly revised over the past three decades.

<div align="center">

✳ ✳ ✳ ✳

</div>

Paolo Soleri is a wiry man of medium height born in 1919 in Torino, Italy. After an education that culminated in a Doctorate in Architec-ture, he came to the United States in 1947 as an apprentice to Frank Lloyd Wright. He was with Wright only a short time, after which he settled in Scottsdale, Arizona near the Wright winter headquarters. Here Soleri supports himself and his immediate enterprises, on his estate, which he calls "Cosanti," by making ceramic and metal bells.

In the years since taking up residence at Cosanti, Soleri has devel-oped, ever more subtly and skillfully, a philosophy of architecture and city planning based in some detail on the thought and work of Pierre Teilhard de Chardin, a Jesuit anthropologist-paleontologist-priest of France with unique ideas and terminology for expressing them. The gist of the Soleri creed seems to be this: Real truth (whatever else it may be) is self-authenticating. All else contains the seeds of its own destruc-tion. Or, to put it a bit more fully in his own words, "There is an inher-ent logic in the structure and nature of organisms that have grown on

this planet. Any architecture, any urban design, and any social order that violates that structure and nature is destructive of itself and of us. Any architecture or urban design that is based on organic principles is valid and will prove its own validity."

Perhaps the principal concern of Mr. Soleri has been urban design, and in recent years his town, Arcosanti, has begun to rise on a plateau 3,700 feet above sea level, seventy miles north of Phoenix. Dr. Soleri and his students are doing the actual construction. About his town Paolo says, "The care of the citizen is the sap of the city. But one can care only for that which one loves. A lovable city is the key to a living city. A lovely city is no accident, just as a lovely person is not an accident." And who is to say that love is not a saner, more practical basis for planning than whatever criterion the New York City Planning Commission is following this year?

JASCA: Paolo, I'm simply overwhelmed by your establishment. It's remarkable. I'll bet you're having a wonderful time.

Soleri: Now and then.

JASCA: It's so complex. There are so many strands woven into it. How did you happen to come to this country?

Soleri: I came to be with Frank Lloyd Wright.

JASCA: Would you tell me about what happened; how you liked it, and so on?

Soleri: Well, it was a very good experience, a very positive thing. I was with the Wrights for eighteen months.

JASCA: Which of Frank Lloyd Wright's buildings did you work on?

Soleri: Oh, I didn't. I never worked in the drafting room. I couldn't. It's always been very hard for me to work under someone else. I worked a little bit with the construction crews, and I ended up doing gardening.

Gardening was my main activity. And kitchen work, because I couldn't pay fees, so I had to work. Half the time I was in the kitchen.

JASCA: Sounds as though there wasn't too much exposure to the architectural end of things.

Soleri: No, but that was fine with me. The main thing was to be in that environment, you know, surrounded by and using those buildings. I was both here in Arizona and in Wisconsin.

JASCA: The Frank Lloyd Wright communities were among the earliest communes in twentieth-century America. How far did he go with the communal idea?

Soleri: Well, in many ways further than what I can accept myself now. But not when I was there, of course, because when I was there, I accepted everything.

JASCA: How did you come to leave the Wright establishment?

Soleri: Well, I got into trouble. As a matter of fact, I was asked to leave.

JASCA: The Wrights were pretty autocratic, even then?

Soleri: Oh yes, but they feel they have a mission (at1 least they used to) and they wanted to stick to it. I don't know how faithful they are now to the "mission." I haven't been in touch with them for a very long time.

JASCA: The autocratic aura still seems to prevail there. How different from your own group last night at the picnic at Arcosanti.

Soleri: True. I agree, but the differences are not all positive.

JASCA: Say more?

Soleri: Well, we are just beginning, now, to try to become civilized, and as you saw yesterday, we have not really made it. It's important to use some of the traditional ways, to do things with less roughness, a little more subtlety. Things like feeding yourself are more enjoyable if they are done with more subtlety. It will take time.

JASCA: You felt that the occasion yesterday was, well, sort of primitive, then. I did too. It was part of the charm.

Soleri: It was primitive because we are still living on a building site. What you saw were the results of attempts by the young people to reject the sophistication of "the civilized way of doing things." We are seeking a balance between the decadence of our civilization and the roughness of being savages.

JASCA: Could you fill me in a bit more?

Soleri: Arcosanti, the town we are building, should allow and encourage us to be a little more sophisticated. Which is one reason we build, instead of just sitting around talking. Another reason is to try and convince the young person that there are many things which are valid about, and in, the past. The past is not all false, not all fraudulent and negative. It's also an accumulation of great wisdom and respect for life, the ability to cope with routine, and so on.

JASCA: I suppose you settled in Arizona because this was what you knew after your year with the Wrights. You made a fortunate choice, it's beautiful country, just gorgeous.

Soleri: Well, I think it's very beautiful too, very sculptural in a way.

JASCA: Speaking of sculpture, were you interested in sculpture when you came here?

Soleri: Not really. I have a background of what you call fine arts schooling, so I had a little training in design, in plastics, and so on. But sculpture? I "do" sculpture occasionally, but I don't involve myself enough to be called a sculptor. No, the main interest is to make spaces which are usable, buildings which are in themselves sculpture. To me, the city happens to be largest of those buildings.

JASCA: Then as I see it, you use your bells (which are in a sense sculptural) as a means to an end.

Soleri: No, there's more to it than that. I like to use my hands. I think it's good to use whatever skills you have, physical skills. So the making of my bells is more than just a means to an end. It is a way of developing a sensitivity, as well as a source of revenue.

JASCA: Do you sell enough of the bells to —?

Soleri: We sell enough of them to have a very easy life if we wanted just that.

JASCA: Let's talk a little about Teilhard. So much of your terminology, your vision, the social prospects, and the development of evolutionary themes are related to the ideas of de Chardin. Did you ever meet him?

Soleri: No. No. I never knew he existed until after he'd died. But as soon as I found out about him, I got all his books. And I found confirmed there what I was trying to say myself, and in a much more intelligent way.

JASCA: What did he do for you?

Soleri: Oh, he's a very, very important figure for me. If it weren't for de Chardin I would not feel so certain about my own work.

JASCA: I have read a number of his books, too. His picture of the emergence and development of man, and of his future as well, is so sweeping.

Soleri: Yes, and his optimism. That's what strikes me. There is so little optimism around these days.

JASCA: Is there any relationship between your handwork interest and the nineteenth century school of William Morris in England?

Soleri: I never had first hand knowledge of Morris' work. You know, it's funny, but that keeps cropping up. I was never interested enough to get involved with Morris, and maybe I should, because there are some parallels, I guess.

JASCA: His big thrust was an attempt to counter the Industrial Revolution. In his view industrialization was an unparalleled disaster to be resisted with all the resources that could be mustered.

Soleri: Yes, and here I might differ with Morris, because I have always felt that the Industrial Revolution is a necessary step. Oh, I can see the bad things about it. But so much of the world of crafts and arts is skimpy, so superficial, that the danger of giving mankind back to the craftsman is not to be risked, even if it ever could be.

JASCA: So your own plans and thinking really reach out to embrace the Industrial Revolution?

Soleri: Yes, I think we should come to see industrial technology as an extension of the technology of the flesh, the biotechnology which is the development of life. Something important happens, new consciousness forms when the two begin to weld. Some of our biotechnology is superseded by, or is helped to function better by, technology. If you can look at it in that framework, then technology is a logical next step. But naturally industrial technology must never become the master. It has to remain the instrument.

JASCA: And that's what is happening with the automobile? It's becoming the master?

Soleri: Ah, yes, the car! Unquestionably it's become the master. But it's not the only thing. So many of the things we have invented are being used in a twisted way, so that technology is becoming a very dangerous thing, a damaging thing. I think one reason is that technology is an over-simplifying kind of device. You turn to technology with a complex problem and it "peels off all the dirt," so to speak, makes it easy to do. We become so fascinated with the process of problem solving, with technology as a thing in itself, that we fail to notice whether the answers we are getting are positive or negative in terms of human values.

JASCA: There seems to be an ethical process involved here. People use the technology as a means of becoming powerful, of exploitation, of

enriching themselves in a financial sense, and this somehow triggers something in the technology itself that turns upon the people who do that — both from the production end and the consumption end — and leaves them impoverished spiritually. Does that make sense?

Soleri: Oh, yes. We're always talking about the wealth of this country, but are we really so rich? Powerful, yes, but the rich life escapes us. And one reason it escapes us is because we have made such poor use of our technology. We just might be the goats, the sacrificial lambs, for those who will come later. We are sorcerers, able to harness energies in a new and unprecedented way, but somebody else will have to make sense out of it. Our imagination takes us only so far.

JASCA: Do you think our young people can do any better?

Soleri: Yes. If our young people can avoid becoming too arrogant, then I think they might make sense of the situation. But for the moment there is quite a bit of arrogance, you know. They know everything. *Nobody* knows everything. If people develop from zero to seventy or eighty, there must be a reason for it. And so we cannot stop at twenty or twenty-five and say, "Now I've got it made," ignoring what a person learns beyond his teens and early maturity. But perhaps there is a turning back now. Many young people are beginning to feel that they need more guidance than they thought they needed.

JASCA: What do you mean by that?

Soleri: Many young people are desperately looking for guidance again. For a while they broke with all discipline, broke all the rules, and now they are finding out that you can't live without rules, without discipline. For in its essentials life is discipline, by definition. You take away the discipline, the biological discipline, and there is no life. It's just as simple as that. There's no reason to believe that on any level which is above the biological we could do without discipline. It's absurd.

JASCA: And you feel that young people have really given their thing a good try now —

Soleri: Yes, and it was a good try, probably an important try. But it was doomed, I think, to fail. It's not so much the fault of the young people, though. They were told that they could break with discipline, could go out and do anything they felt like. The professors and the leaders of youth probably found it easier to go along than buck the tide. That's where you'll find the real guilt. Leaders of youth have been guilty of copping out, I think.

JASCA: Well, there didn't seem to be much of that spirit in the young people here last night. When the truck came they all jumped up and went out to help unload.

Soleri: Oh, yes, I think in general they are pretty good. But then we make some kind of a pre-selection through the printed material we send out. We don't select in a sense of saying, "Yes you, you, and you." We just give out the program — which is pretty stiff — and those who feel they can accept it are self-selected.

JASCA: Do you have any great problems having the males and females at camp together?

Soleri: The experience of a commune, a community outside the family, has not been all that wonderful for many of our students. Many young people who have tried it might feel different about the family now, if they could bring themselves to go back. There's something in the family that we can't find anywhere else, and it's very simple. It's your father and your mother. They are biologically identified with you, and you can't get away from that. If they didn't exist, you wouldn't exist. Anybody else or anything else could be different to you, but not your parents.

JASCA: This seems to be just the moment, Paolo, to bring up reservations about what I've seen and heard here these last two days. I see the real problems of mankind, the difficulties in which we are all so deeply immersed right now, stemming from a failure of nurture. The consolidation of a sense of personal reality and worth comes from and through

one's family life and up-bringing. Much of the human race isn't getting this, but still, we simply have to have it to be whole. I don't see how this problem is going to be touched by the city, how we can be better people and live more graciously in the city, unless we devise some way of attacking and solving this fundamental problem first. What do you think?

Soleri: Well, people, you know, are part soma and part psyche. We cannot separate the two. And if you want to have a psychic life which is more balanced and more sensitive, you have to have a good somatic life too. For the whole person, the psycho-somatic man, the environment is almost half of reality. Up to now people have had a queer way of ordering and constructing the environment. I build my little fortress, stuff it full of goods that belong to me, and then I shape my life to preserve and extend this domain. Well, it happens that in this day and age that particular pattern has shown itself to be pretty shallow. Our children somehow grasp that. The discrepancy between what parents say and what parents do keeps building up within the psyche of the child 'til it's difficult for a child to respect his parents. So much so that the child loses both the desire and the ability to learn from them.

JASCA: But will things be any better if you lift a family out of suburban Scottsdale and put it down in Arcosanti?

Soleri: Oh, I think so. First of all, you would so physically re-integrate the behavior of that family into the behavior of society that it would be almost forced to take on new responsibility. The family would have to accept the fact that it is not isolated, that it is not king in its little domain, not an entity responsible only to itself, and so on. Second, the family would have to accept limitations as far as the physical opulence of its environment is concerned. Third, it would find in the city many things that the family cannot deliver — the real culture side of the community. I think it might really get into relationship with the well-springs of life, might pull things together, and go on from there.

JASCA: I hear you saying that if the transfer is made and the family is

put into this setting, then new stresses, set up by the social situation, will set up an entirely new life-view or model.

Soleri: Well, it wouldn't happen automatically. You have to have a deep change of heart or the environment can't do very much for you. We're not setting up something that is sufficient, but we are setting up something which is necessary. We're creating a setting in which a change of heart might come to birth. In other words, it's not sufficient to build a "perfect" environment, and then expect a perfect society. You could have a "perfect" environment and an awful society, or vice versa. But an inspiring environment might help. It's up to social planners, politics, economies, to do the rest.

JASCA: Is there not some social thinker or school with whom you could ally yourself, to work at this from both ends?

Soleri: Up to a point I would accept Skinner. If we can bring up a child to understand that punishment is not malicious, but is something that the world, that reality, will deliver if you don't somehow make sense, and that reward, too, comes from reality when you do make sense — then up to a certain level I think that works. My own reservation about Behaviorism concerns creation of the future that way. As I see it punishment and reward tend to keep things going as they are.

JASCA: You have spoken about "the aesthetic process" as a force in our culture. Say something more about that.

Soleri: Recently I worked on a paper called "The Religion of Simulation," in which I say that our conception of God is an hypothesis, a picture or simulation of a reality which we may know in the future. It is a very optimistic, a very powerful, and very helpful simulation as long as we remember that it is a simulation and are prepared for surprises. Now, in order to reveal this godliness, to make this possibility a reality, there are two roads we can take, which I call "sainthood" and "aestheto-genesis."

JASCA: And what?

Soleri: Aestheto-genesis, the generation or genesis of the aesthetic world. Sainthood is a synopsis or telescoping of the process of moving from mind into spirit, from psychic energy to God. Through suffering the saint or martyr is able to present an almost god like image or aspect. Sainthood doesn't have to be a person, it can be the experience of a people, maybe like something that happened to the Jews during the Second World War. That's one road.

The other road is to transform matter into beauty, into aesthetic beauty, compassionate beauty. This transformation, too, takes place in the presence of anguish, of that suffering which is part and parcel of life. Beauty cannot be created through logical processes, through rationalization, through justice, or any such instrument. It must come into being through its own special process of creation: aestheto-genesis. Matter has to be metamorphosed, through anguish, into the aesthetic, the spiritual. As the number of these transformations builds, a god-like condition begins to emerge in consciousness. So we are revealing fragments, infinitesimal fragments of God by the aesthetic process.

JASCA: Then it's almost like a manufacturing process. Some people have the power to operate on the material and create in their transformation of it, according to their aesthetic sensitivity, a fragment of God.

Soleri: Yes, you have got it. Only, of course, it's not an automatic thing. Creativity and anguish don't arise together automatically. A person might just go out of his mind. Anguish might mean destruction. But sometimes, in some circumstances, and not very often, a man is able to transcend his anguish. He can do so only at a given moment, in specific circumstances. The next time he has to start again. Each time you act, you can act as a fool, as an artist, or as a saint, but you have to do it day by day.

And there is no limit. No matter how much you do, there is an infinity that hasn't been done. An infinity waiting to respond to the touch of your anguish. The more you know, the more you grasp, the

more you imagine you could know, the more you sense the limitless gap between the possible and the real. God is in this somehow. The element of anguish becomes the trigger for a larger expression of beauty that is compassionate, as compared to the beauty of nature, which is dispassionate. A landscape is beautiful, but it doesn't have the compassion of man in it, the thing that comes from his consciousness of his helplessness in the world, the consciousness that distinguishes somehow between good and evil. I think the dilemma of being good instead of being evil is part of the anguish out of which beauty and God are born.

JASCA: Say more about good and evil.

Soleri: I don't know whether it's Augustinian, or where it comes from, but I tend to believe that evil is the absence of good, or it is the consciousness that the universe is not good enough. Consciousness wants to make the whole universe like itself. Wherever the universe is not conscious, it remains in evil, not yet redeemed by consciousness. The battle against entropy is the battle against evil. If there is any possibility of synthesizing everything, of transforming the whole universe into God, then I see the gap between this possible God and the existential situation in which we find ourselves as the shape of our human task. And though I'm not a Behaviorist, I see in Skinner devices which could help us to accomplish that task. Not the answer, but the means to it.

JASCA: Speak about frugality.

Soleri: We humans stand as psychosomatic creatures — 150 pounds or so of flesh — but packed up in that little space is so much! We are each one a marvelous example of frugality. The God of this life has been able to do so much with so little. We are astonishing examples of frugality. Within the immense machinery of the cosmos we are infinitesimal particles able not just to be, but to grasp the immensity of it all.

JASCA: Then frugality is very close in meaning to your "miniaturization."

Soleri: I think you can't escape it. It's really the ability to put much into little. A little matter, a little energy, but such complexity! The wonder is *there*. That's why when I as a person, as such a frugal phenomenon, surround myself with such an enormous heap of gadgetries and stuff, I negate what I am.

JASCA: At our meeting yesterday you said, "We are not just pure spirit, we are matter-oriented, and we should be very glad of it because it's very beautiful to be matter-oriented."

Soleri: I expect a saint would think different, don't you? For the moment, we cannot grasp what "pure spirit" might be. I object to a God conceived of as pure spirit, to one as incorruptible and as great as God is thought to be, so I have to image Him as the implosion of the universe into a point. De Chardin calls it "the Omega Point."

JASCA: Say more about that, the relationship of matter and spirit. They often seem to be pulling in opposite directions, and yet they make a very dynamic tension.

Soleri: One way, not of explaining but of seeing the thing, is to think of spirit as interiorized matter. In other words, whenever you have a manifestation of life you also have a manifestation of spirit, no matter how low it might be — a leaf or a worm or whatever. In every living thing there's an interiorized universe, infinitesimal, but real. What is implied here is that matter, for some reason, is capable of becoming conscious of itself, inwardly defined, innerly oriented. So that the more of those inner universes we can produce, the more we approach the possibility of sensitizing all matter, the closer we approach the apparent intention of evolution. To limit, to say that this process cannot go on forever, is not justifiable, because evolution tells us that the original condition was far different from the condition we have now, that the ecology of the original earth was fire and methane. The gap remaining between us and God is at least as great as the gap between the original earth and now. Perhaps aesthetically we could put limits to the complexification

81

of things, but evolution hasn't done so. Personally, I think there is no limit.

JASCA: You can go on and on, creating more and more complexity in simpler and simpler vessels, spiritualizing, and you will finally reach that point, that Omega Point.

Soleri: About this point the scientist is not ready any more to say, "No this is foolishness." In fact, the scientist himself begins to think that science is not so clever. We can make it all easier for ourselves if we will continually try to observe the phenomenon of life from the beginning to the present. We can say, for instance, that Africa is more spiritual now than it was 300,000 or a half million years ago. It is true that Africa today is a place with lots of problems. The same goes for Europe, for Asia, or any other place. But if we take a perspective which is deep enough, then there is no question that matter is becoming more sensitized, more and more sensitized. Which means, matter is becoming more than it used to be. And man happens to be the spearhead, the most sensitized of sensitization.

JASCA: Then good is "sensitivity."

Soleri: I would think so.

JASCA: Increased sensitivity.

Soleri: Which implies consciousness, self-consciousness.

JASCA: Self-consciousness. What is the self? This is what I referred to when I raised the issue of nurture, of giving people a sense of the goodness of self. People seem to grow up with the conviction that they are not okay, that the self is not good and beautiful. The crux of the problem, it seems to me, is to create a sense of goodness about self — self-consciousness as a child of God. That, I would argue, is salvation, spell it out any way you want.

Soleri: I think that de Chardin has a telling word to offer here. He says that we become more personalized as we become more collectivized.

82

In other words, the consciousness of self is going to be greater and better the more we are socially oriented. The more we are "men for others." So if we "fit" within the family of man, we are going to make it as persons. If we don't fit into the family of man, we are going to fail as persons, too. So there is no contradiction between the collective and the personal. In fact, one is the stepping stone to the other one.

JASCA: That I see. But I also see the enormous strain that this creates in individuals.

Soleri: Yes, but that might be because we are just beginning to experience the thing. We might be much more optimistic if we realized that where we stand is not even at the birth, but at the conception of something. We are barely conceived. It is not yet apparent what we shall become. We're going to go through a number of stresses, even crises, before the birth comes. And each trauma is going to have its victims.

JASCA: One would have to have a pretty strong belief in the worthiness of self to cast one's lot in that direction rather than in amassing great personal power. Perhaps that's why people do it. They drag all this stuff up and keep it around themselves as a barrier, a bulwark, or defense against the threat of tension.

Soleri: Well, yes, we have to up to a certain point, you know. It's hard to grow and change in the presence of tension. We grow when we let go, relinquish. And we have a lot of growing to do.

JASCA: Well, it's something one just has to believe in.

Soleri: Yes, and my central conviction is that in order to maintain that sustaining belief we need the right kind of environment.

JASCA: You think the environment can teach people?

Soleri: No, it's a necessity, not a sufficiency. We must not fool ourselves into thinking that good ingredients and a good cookpot are going to produce automatically a good soup, but we do need some kind of container in which to cook a soup. The better the container, the better

chance we have of a good soup.

But we are not dealing with a simple thing like soup. We are dealing with a container which is so much more influential on whatever we do. Environment matters. If the earth were just slightly different from what it is, we would be quite different from what we are. Environment is always there, modifying us for good or for evil. That's why I think it's so important. And we have the choice. It's very much up to us to take the right road, or to ignore it, to get into a dead end and sit there in opulence until the end.

JASCA: Paolo, there are two forms that seem to fill all of your work, the circle and the square. Nearly every shape at Arcosanti is some combination of the circle and the square. Do you feel these have some relationship to your philosophy, or is this just a personal preference?

Soleri: I'm not very versatile in those subtleties. I never was very taken about symbols, about a possible relationship between the geometry of things and the meaning of things. I don't know, it's just that I like the framing of the landscape in that way. But I don't believe in pure functionality. In fact, I believe that the real meaning of the city is in those things which are in some way mysterious enough not to explain themselves immediately. The evolution of the biological creature doesn't come through needs finding forms through which to be satisfied, but by forms that are defining new needs. First comes the organ, then comes the function.

JASCA: The form is the first thing?

Soleri: Then comes the content. That doesn't mean that each form is going to find a content. Most forms are failures. We see this so often. We build something out of need and find out it isn't right. Then we explore to see what it can do. Like penicillin. It's not rational, but isn't this how life has really evolved? Not through needs, but through survival. Survival that has been achieved through new mutations, new things that didn't have any meaning at the beginning. You take the eye, for instance. You have a certain level of life, there was no sight. Well, nobody, no crea-

ture, was really thinking about getting the eye, obviously. It just happened that some fibers became sensitized to light. So the form came and the function followed. And I think each little step in genetic development is due to mutations that originate by accident and become survival devices.

JASCA: When I see your circles and squares I think of the landscape design work of Roberto Burle Marx in Brazil. You know, his extremely free form, flowing shapes and all. How very different from Arcosanti. The idea kind of flashed across my mind of the Apollonian and the Dionysian, the clinging to order and the disciplined, as contrasted with the exuberance of Marx.

Soleri: Yes, in a way the instinctual and the intellectual. The Dionysian is the instinctual, the Apollonian the intellectual.

JASCA: Does this seem valid to you?

Soleri: A little. In fact, somewhere I noted that my work in arcology was first Dionysian, and then became Apollonian later on. But I think we should always try to fuse the two so they're part of the same phenomenon. You could say these two are characteristic, one of the origin, the other of the end. We begin as instinctual phenomena. We often end up being intellectual phenomena.

JASCA: In a way it's a great loss.

Soleri: Yes, this is one of the disadvantages of technology. It tends to transform the instinctual into the intellectual. And so we might end up becoming intellectual robots instead of the instinctual robots we now are in many ways.

JASCA: The problem is to keep a balance.

Soleri: I guess so. In a way we must rise above both extremes. It's not just enough to be in the middle. I think we have to get away from both of them to realize the best of either.

JASCA: How do you picture this?

Soleri: As a consciousness which is able to make the best use of both the instinctual and of the logical. Perhaps you could call this compassion.

JASCA: Do you think the church, organized religion, will have any place in your city?

Soleri: This is a hard one. I am so convinced now that religion is in its essence an attempt to predict the future that —

JASCA: An attempt to what?

Soleri: To predict the future. At it's best the church is a predicting institution, I think. And I believe that in that sense the church is going to have a very central position in anything we do. You can't escape it.

JASCA: Then you see the theological task as continually arranging the emerging bits of God into a coherent picture, helping the full revelation to emerge into consciousness.

Soleri: Well, yes. If we accept for the moment that we have been witnessing the transformation of matter into spirit, then the whole ecological process becomes a theological process. It's inescapable. So matter longs, strives, to become God. It follows that whatever we do that makes sense ecologically is going to make sense theologically.

JASCA: So if the church has a role to play in your city, it's to gather up the fruit of the experience of what takes place there and sift the useless and the bad out.

Soleri: That's right — sifting out the enthropic, which is the pollutant.

JASCA: And gathering the other together, the conscious, the sensitive, continuing to make predictions about what is possible.

Soleri: Yes. Now one of the dangers is that if we stop seeing the church's visions as predictions, if we begin to think of them as great perfection,

then we might be tempted to remain static, or go back. There's nothing to go back to as far as I am concerned. The Garden of Eden is at best the beautiful animal condition — perfect in many ways but deprived of consciousness, dispassionate, and so on. What I call the aesthetic is the sense of compassionate beauty, so we cannot go back to those conditions. We must go forward toward God, not the God of the genesis, but the God of the end, whom we know only hypothetically. If the church can become this dynamic kind of tool, then I think it is going to be in the very middle of things for a long time — the central thread upon which life can build itself. But if the church is some kind of nostalgia for a past glory, then it might be stifling.

JASCA: There's a place in St. Paul where he talks about the overlapping of the ages. As he describes it, Jesus Christ reached forward to a new age and pulled it back into this one, so that all of us can experience something of what is coming, now. This is why he came. What Teilhard called the Omega Point becomes present, as a kind of foretaste.

Soleri: Strange! That's the same thing I call the synopsis of sainthood. You remember I was saying before that the saint is a person able to make the future the present through his suffering. It's all so tightly woven.

JASCA: This idea in Paul, this spiritual posture, is even related to the idea of possession. We can allow ourselves to be possessed by a spirit from far in the future. In that sense, I don't see the function of religion as nostalgic, holding on to the past, but really reaching forward. I see real harmony with your ideas there.

But to go on. I'm a little concerned about personal freedom in the city. For instance, a part of my joy in life is in gardening. And I have to have my own ground. I couldn't give myself to a garden where my neighbor's dog or child could come in and ruin it, which might be acceptable because it is communal space. I'd have to shrink my life by that much. I couldn't stand it.

Soleri: When a person feels strongly enough about something that's very basic to him, he should hold on to it. But I think that for many people this idea of "being in touch with the ground," of "loving nature," is just, you know, talk. And there is room in the city, after all, for variety and specialty. I'm not advocating 5 billion people coerced into cities. But I think that precisely because we are going to be 5 or 6 billion, cities are becoming even more a necessity.

JASCA: I see that.

Soleri: So if we can make more effective cities, it would give more space to people like yourself who feel the need for real contact with the earth. Or it might not even be done on the ground. It could be done on many levels. We do not yet have blueprints for such fine points. We are still at the stage of methodology. It's one thing to devise methodology and another thing to apply it. I'm not saying that I can apply it. I'm saying that the way to grow is to work, to make a serious effort, to begin.

JASCA: You've said that you're designing a pot, not the recipe for the soup. But could you make a few predictions about life in this new city? What about youth? How will the city enhance or improve the chances of young people to become sensitive?

Soleri: The city is an information medium, a living environment, and it will become a classroom, which means that in the city we will have enough things of different kinds happening in different fields, on different levels, that the young person won't have to go to school in the traditional sense. The city will be his school, so that when he opens the door, the door of his living place, the child will simply inject himself or herself into the city. This happens now! So I think as a learning environment, it had better be the best. It can only be the best if it is full of life, full of options, full of things that entice the curiosity and the sensitivity of youngsters. I'm afraid that doesn't happen now in suburbia, nor in the ghettos.

JASCA: What about law and order? Don't a lot of people use anonymity as a cover for destructiveness?

Soleri: Well, yes, but then environment won't help very much either way. No matter in what environment people who are full of resentment find themselves, they can slip into misbehavior, or worse.

JASCA: You see vandalism as mostly retaliation, then?

Soleri.: Sure. If injustice is rampant, it's very easy to become destructive. I think that to have law and order we have to build ourselves into a reverential frame of reference and mind. You can't do that when you only look at the psychological, or only at the somatic facts. You have to put them together. Then you can build reverence toward all your surroundings, including people. You begin to take care of the things around you. Without this reverence there is only coercion, be it coercion through the dictator, coercion through ownership, or what have you. I take care of what I own, and the hell with what's around me. I'd better take care of it, because otherwise I am going to be dispossessed. Isn't that the system we are using in general? How can that work? A working system is one that helps me decide, willingly, that I am going to respect and take care of what surrounds me because I have a reverent feeling about it.

JASCA: What do you think will happen to people who refuse to learn respect, or who won't live in cities built along the lines you propose?

Soleri: I think it's all a matter of time schedules. If we say that within two hundred years everybody's going to be in one of our cities, I think it's fine. We don't have too much time left, but we still have plenty to let people make up their minds. On the other hand the idea might go underground for a number of generations before it comes up again.

JASCA: You don't feel its critical at this point?

Soleri: Yes, I think it's critical. It's critical that we make this quantum jump. I think it's the only way to become coherent again in the environ-

ment without destroying ourselves. And we aren't likely to learn this lesson without punishing ourselves a lot because we were born into an atmosphere of conspicuous consumption; it's part of our life. But the only way of maintaining the advantages that technology has given to us is to make this quantum jump.

JASCA: In conclusion, what do you think are the most hopeful signs in the world at this moment?

Soleri: Well, one thing is the breaking down of many of the interfaces, many of the diaphragms that have isolated groups from other groups. Then there is the information network. We don't seem to be making very much use of it now, but at least we have instruments that can bring to us what's happening on the other side of the world. If we can now take technology and tell it what to do instead of letting it tell us what to do, then we will soon be ready for the leap.

JASCA: And what creates the gravest doubts for you?

Soleri: Run-away technology. The exhilaration we get from the power we acquire and the destruction of resources accumulated through the evolutionary process. I see this as potential spirit being burned away, and I think the process is irreversible. Those things happen only once. There are time slots for everything, and the time slot for accumulating those energies is in the past. I think our gravest problem is the technological rage, the rage to do whatever is feasible. There's a difference between desirable and feasible.

JASCA: Of course.

Soleri: We cancel the difference, and we know that we can sell anything we produce. Result? Anything which is feasible is made. We create a catastrophic avalanche of junk because it is feasible, when we should be paying attention to what is desirable. I call that "a better quality of wrongness." We're getting very skilled — skilled at doing the wrong thing in better and better ways.

A Container For Equity

"It is a necessity to make the city package small enough so that both the man-made and the natural are at your disposal. There is a limit to the size of any organism, whether biological or para-biological. The city is no exception to this imperative."

Jonathan Pressler interviewed Paolo Soleri in his studio at Cosanti in 1973. Their wide-ranging conversation, published in *Noosphere*, volume 1.1, touches repeatedly on Soleri's understanding of knowledge and how it is expressed in his work on arcologies.

* * * *

JP: After reading your book, *Arcology: The City in the Image of Man,* I have a fair idea of what an arcology is. But in the book you do not explain how the idea developed. I've heard of the Mesa City project, which I imagine was a prototype arcology. Could you explain Mesa City and how working on that may have led to the idea of arcology?

Soleri: I put the Mesa City problem to myself. I was interested in conservation so I started with what was theoretically a wasteland parcel: the mesa. Usually they are rocky and arid. There's very little soil because they are windswept plateaus. But they are often very beautiful spots. So I began from there. I don't know exactly how the idea of arcology came about, but sometimes a semantic device tends to trigger ideas — at least it does for me. One day I somehow decided that "arcology" was a term that emphasized something that wasn't emphasized before. I had been working on Mesa City for a number of months, and I kept feeling that I was not getting down to the main problem, which is an information problem, including all the many ways of interacting between people and things. And what appeared more and more

was that the information structure that I had then designed was not the best model that I could work on.

After considering the problem in a more radical way, I decided that distance was the essential variable. The communication of information is at the heart of the problem. If an environment is to be the ideal setting for information, it should afford access to the information sources and centers so that we have the fullest, most all-round kind of knowledge. That means we need all sorts of devices for getting to the information, including presence. By presence I mean the actual relationship between two information centers: one person with another person.

So you need direct environmental information and you also need all the other kinds of information, which can be very subtle and very sophisticated, reaching us through devices like your tape recorder, for instance. In order to have both of them, you have to have a lively and intimate environment. That's where the city structure becomes very basic for the information which is the foundation of life. It's quite evident that if you want to know something about another person, if you want to know as much as you can, you try to go beyond a conversation by way of remote devices. You try, in fact, to live with the person or live around the person as much as you can. That's the environmental information I'm talking about. I think that a compact city — an arcology — would be the most lively setting for information transfer on all levels.

JP: There is one phrase in your book, *The City in the Image of Man,* that I think best expresses the goal of arcology. You say, "If society is able to put man on this borderline of nature and neonature (the man-made) and keep him at the same time a vital citizen, it is there at the cleavage point that man, the lonely individual, may seek and find identification." It seems to me that the purpose of an arcology as a city, then, is not only to make man a more responsible citizen, but at the same time to make him a more creative person by placing him at this confluence of natural phenomena and man-made phenomena where he could draw the best from both rivers.

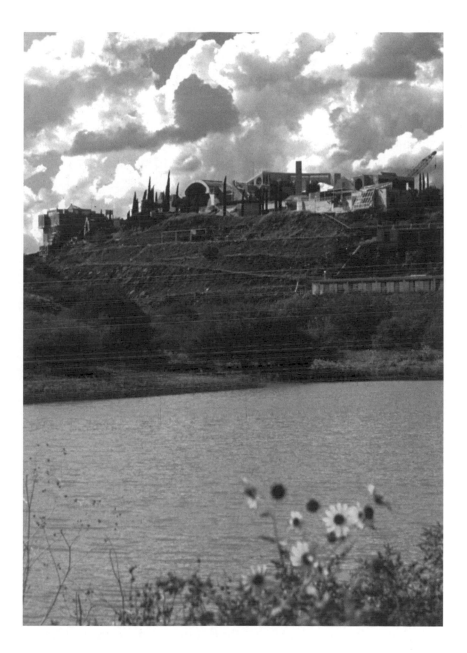

Arcosanti

Soleri: Yes, I would agree with you. There are definite creative potentials when in that position. Evidently, in order to develop life needs challenges, and the challenges very, very often deceive our senses. So the more our senses are stimulated in a varied yet balanced way, the less likely we are to misinterpret what we perceive. And in the variety of information that we confront on the edge between the man-made and the natural, there are challenges that are going to move man in creative directions.

There are three possibilities. One is to put man back in what we call the natural state, another is to put man into a totally artificial condition, and the third case is to place him in-between. We should rationalize which of the three is in the best position to evolve. I would say that it is the one with access to both the natural and the neonatural, not the others, which have access only to one or the other.

JP: One thesis which you have discussed often in the past is miniaturization as evolution. You have even gone so far as to say, " 'Miniaturize or die' has been the key rule for incipient life." This appears to me a rather extreme position.

Soleri: Well, I would say that it is too gentle. Perhaps not "Miniaturize or die," but miniaturize or not be born, at least not as an evolving creature. Real life is evolutionary life. It's evident that the protozoan, for instance, will survive, and might even survive man. You can tell it, Miniaturize or die," and it is going to laugh at you. The fact is that it is a living example of the power of miniaturization. However, it is not survival which is interesting, but evolution.

JP: I see. But in an arcology we are talking about the physical miniaturization of the environment, the miniaturization of the city as an organism. Isn't there a limit to the process, a point beyond which the individual organisms which make up the city organism begin to suffer?

Soleri: As an evolutionist I believe that the anthropoid developed into a human being because it was able (wasn't conscious of it, but was able) to really miniaturize and complexify more of the environment within

94

its own nervous system. To say that now we have reached the limit is to say something that might be true, but which we don't know. The fact is, it's not true in the sense that man at this point (no longer merely life at the threshold of becoming human) has moved into a new miniaturization through the development of the outer technological environment.

JP: So you're saying that if there is a possibility for enrichment, then miniaturization is a necessity?

Soleri: Yes, it has always coincided with enrichment.

JP: Still staying with miniaturizing, but moving to the subject of government: If the miniaturized state is the most efficient state, where does that leave democracy, certainly a very inefficient, ponderous form of government? Does miniaturization point to a technocratic dictatorship?

Soleri: Not necessarily. It is essential to balance miniaturization. If you miniaturize too much in one sector and do not proceed at the same pace in another sector, you unbalance the creature, the society. I think that the problem is to be able to somehow move in all the sectors in a balanced fashion. That might be the problem with democracy at this point. The problem in general in any kind of political situation is that we must move in so many directions in order to bring in a most efficient condition without making a monster.

Miniaturization does mean more efficiency. Although Hitler was very efficient in many ways, the priorities were such that the more efficient he became the more monstrous he became. For example, there was something good in trying to come up with a physically healthy nation, but this was based on the idea that you had to eliminate those people that, according to the Nazi theory, could not be considered healthy. So there was a basic twist that made impossible a balanced development, whatever such an approach was seeking. The danger of efficiency is that it's taken as one independent branch of life. It is very dangerous that people tend to make an idol out of efficiency. Then efficiency becomes the aim instead of remaining a means.

THE URBAN IDEAL

JP: You say that nature maintains a dynamic equilibrium, a congruence with its parts. Would you say that at this juncture of history human actions which would destroy equilibrium in the environment are ethically wrong, as well as being practically destructive? In a sense, then, that equity and congruence have merged?

Soleri: We all realize that equity is essential. In every nation, though it might be hypocritical, there is this pretense that we must build equity into society. The building of equity is not really compassionate, however, unless it is built within congruence. This means that it doesn't help to have a nation of saints if those saints are going to die because of incongruence within the environment. So the only real equity is the congruent equity.

The really compassionate society is the one that has equity contained within an ecological congruence. In the end an incongruent act is an immoral act. This is why I make a distinction between piety and compassion. An example of the pious person might be the social worker who persists in his help for others (and may even win many battles) when the war he fights is lost. Whereas the acts of the compassionate man or society may seem to be very harsh, but within a larger perspective can be seen to be the right course, the effective course.

I point out in one of my papers that to halt the exodus of the urban man into suburbia in the end might be one of the compassionate ways that this society has to remake itself. By emptying the city, the American society might be doing the most revolutionary kind of act that we could conceive of because it is setting the stage for a new kind of development, which might be the implosion of the scattered society into new centers — the reversal of the exodus.

JP: Another idea which is essential to an arcology and is central to the flow of information is the centralized brain which stores past information as a tool for the citizens of the city. What would you say is the difference between the function of this mechanical brain and that of the thousands of individual minds of the populace?

96

Soleri: You can say that a computer is a machine collecting and manipulating information. It might also be an efficient instrument for ordering the logistical structure of the city. But the human mind is the machine that probably has the skills to go beyond that and transform information into knowledge. So, I think that one — the computer — would specifically be an information pool; the other — the mind — would be an information pool that has the added ability to come up with knowledge.

You can go to the library and start to gather information about the apple, for example. But suppose that we are deprived of access to the apple itself. I would say that if this deprivation is final, then what you know about the apple remains information. However, if you can take an apple and eat it, or if you can watch the tree in its process of development until it bears fruit, and so on, then you have an unmediated experience of substantial qualities.

What I am saying is that an environmental consciousness is necessary to develop knowledge. If you stop before that, if you tend to be a purely analytical person, I would say that you are still dealing only with information. You are not going to be able to adequately extrapolate full ideas because you persistently try to separate things without being able to put them together again. So I would say that the analytical mind has more problems than the synthetic mind in coming up with a knowledgeable consciousness of what things are. In effect, I am saying that the computer cannot taste the apple.

This points to a great chasm between the analytical mind and the synthetic mind, between a wealth of data and knowledge. The analytical person could be full of information and be a pretty dull source of creativity. Another person might have very little data and be creative. I think this is very evident in the field of music, where some of the greatest composers wrote masterpieces in their youth. You cannot say about them that they had an enormous amount of information. It just happened that somehow their knowledge was very substantial. By knowledge I really mean the depth, the intensity of their experience. And I

would be very skeptical of thinking that the absorption of all data means that automatically you are becoming a better person or a more creative person. There is something else, and this something else is evidently very intangible, so it's very difficult to talk about it or to discuss it or put it aside and examine it.

In a way you have to suffer your data, and if you sit at a console and keep gulping data, but don't digest it, then you remain pretty shallow. Again, it's trying to understand what an apple can be without having hunger, without having access to the apple, without a nose to smell it, without the sensors in your mouth to taste it, and so on. Between the two there is the difference between dead information and live information. If someone were to create an apple out of the formula or data, in a computer without having any experience of the environment, he would probably come up with a plastic apple. It might look like an apple, but it's not an apple.

JP: One interesting question about the city you are proposing is: Will it be the cultural forces which pull the city in instead of letting it swing out uncontrolled, or is it going to be the physical structure that doesn't permit the city to expand into the sprawl which we witness in today's urban centers? It may be all well and good that government and industry set about building the physical structure of an arcology, but building something and commitment to living in it are two different things.

Soleri: Undoubtedly compassion and a knowledge of environmental congruence show us that the animal (the city) must be self-contained.

JP: Yes, but if you have a working environment which is so distasteful that you want to put as much distance as possible between your working life and your private life (as is certainly the case today) then the immediate need to escape might overcome the more remote concern for congruence in the environment. Suburbia feeds on this kind of conflict.

Soleri: There the inner congruence is failing. That's why you reject this

containment and move out. Evidently the difficulty is to have an inner congruence before you can begin to ask the people not to burst the skin and disperse. But if the container makes sense (and to construct a sensible container is not easy) then there must be an acceptance of limits which are defined by its physical limits. Not only that, but I think it is a necessity to make the city package small enough so that both the man-made and the natural are at your disposal. There is a limit to the size of any organism, whether biological or para-biological. The city is no exception to this imperative.

JP: So our social institutions must structure themselves to the limits of the city container?

Soleri: Yes, but keeping in mind that containment is not isolation or segregation. In fact it is the opposite in the sense that you are trying to optimize the liveliness of the creature.

JP: If we take an analogy comparing modern man to Noah with a mandate to save what is good of the earth, would you consider arcologies to be our "ark"?

Soleri: Well, survival doesn't interest me, not in the sense that I don't care about survival, but in the sense that if I knew that survival was the only reason for doing anything, I would feel pretty discouraged. I would say that Noah's ark is the earth at this point.

JP: So an arcology is much more than an ark?

Soleri: Yes, it's not a conservation. It's an evolutionary attempt. The ark was an emergency device to go through a crisis, but the arcology, expressing the necessity for a lively clustering, is not an emergency device. It exemplifies the ruling methodology. The view of arcology as ark expresses the fact that it is also a survival mechanism, and the threat of environmental emergency might create the urgency to emerge into something new. An arcology as a survival mechanism is a means to an arcology as a better living structure.

JP: Do you think that you might be considered a utopian thinker by generations in the future?

Soleri: Suppose for the moment that you could project two realities, one in which arcologies existed and one in which they remained only conceptual. Evidently, if the idea is realized, it would not be utopian because it has become a functioning entity. But in different circumstances where there is no concrete example of the idea, it will be considered utopian. So I think your question depends very much on how we build the future. We can build it one way and make an idea into concrete reality, or we can take another course and have the idea remain only utopian. Where that leaves *us* I don't know.

Survival or Transcendence

"We are what we are because there's been a sequence of processes which somehow, one step at a time, have defined man, but we could be a thousand times more perfect or a thousand times less perfect. I don't see any perfection in the processes of nature creating us."

This conversation took place at Cosanti in 1982, and was originally published, in a longer version, in *Deep Ecology*, an anthology of interviews with prominent thinkers edited by Michael Gosney. It covers a broad range of complex ideas — from art to the environment to the nature of consciousness — reflecting the varying concerns of its six participants.

<div align="center">

* * * *

</div>

Paolo Soleri was born in Turin, Italy and received his Doctor of Architecture degree in Italy. He has lived and worked in Arizona since 1956. Soleri is an architect, philosopher and craftsman. He has become known throughout the world for his innovative urban designs, called "arcologies," and for his ceramic and metal windbells and sculpture. Participating in this conversation with him are:

Michael Tobias, formerly an Assistant Professor of Environmental Affairs and the Humanities at Dartmouth College, with a Ph.D. from the University of California at Santa Cruz.

Michael Gosney is a writer/artist with a diversified communications background. He is the publisher of Avant Books.

Tony Brown has been an Architect-in-Residence at Arcosanti for seven years.

Robert Radin is an entrepreneur with special expertise in global agriculture, textiles and low-income housing.

Ed Roxburgh is a California-based painter whose artwork is recognized internationally.

Complexity vs. Complication

MT: When someone hears the names Paolo Soleri and Arcosanti, the first impressions are of utopia, socialism, the imposition of communal life as opposed to good old American hedonism. I want to know what Arcosanti is asking about America in terms of what really is ethical, what really is ecological. Right from the core. What do you do? How does that work? How are you going about it? What makes you feel this is the way of the future?

Soleri: If we start with American society (which we can equate very much with Western society, Europe, Canada, and so on), my first observation would be that we are mixing up the practical with the real. Unfortunately, the consequences are quite often not very positive, nor do they make the distinction between that which is real and important, and the immediate reward or immediate results sought by the practical mind. It's like pretending, or deceiving ourselves into believing that we have solved a medical problem by taking care of the aches. We segregate analysis and think, "Eureka! We've solved the problem." I think that's what the practical bend in mind does very well. The auxiliary is technology, which stands to be a limited but effective solution to problems that are segregated so as to find solutions.

So, by adding up all those small triumphs of the tales of reality we miss what reality might be, which is not just a sum of those parts. It is more than the sum of parts. And I think the real requires a reconsideration of this capacity for analytical inquiries. The answers which remain within the context of analysis instead of looping back to synthesis are no answers at all, since they are not capable of responding to the

encompassing problems.

MT: What in your mind are some of the immediate clues to those large scale problems that are missed by the practical mind?

Soleri: Evidently, the ecological disaster that we have been moving into is a very real example of practical solutions that have tended to become the nemesis of that which we are dealing with. So as a farmer, I might do a beautiful job with my fifty acres of land and then discover chaos surrounding my little plot of ordered grounds. So it's the old story of genentropy being created at the expense of disorder. I have to know where I come from more and more. The more I deal with the future, the more I have to know what the past is. Otherwise, there's no way of doing anything in the future.

MT: The very verbs that you're employing right now — "deal" and "know" — what do they mean?

Soleri: "Deal" is to proceed in implementing something which doesn't exist. It's just a wish or an anticipation or what you might call a plan. "Knowing" is a perception and a rationalization of something that has come about and now is stored somewhere. So in order for me to do any planning I need to know what is the reality which I'm going to manipulate in order to produce the plan, to implement the plan. If I don't know what the material I'm going to use is, my planning is even more abstract, even more arbitrary. So the knowledge — whatever knowledge one can have of one's own origin — is very important in order to anticipate.

MT: As you probe backwards do you identify any period in history when a model was put forth that intimated the kind of future harmony you are oriented towards in your work? Was there any period in medieval Europe, in the hunting and gathering societies, during the Renaissance?

Soleri: I wish I knew history so I could give you an answer. *(laughter)* But, in a way, any religious model contains at least some of the elements of the model I need in order to participate in making reality.

103

MT: The future.

Soleri: Yes.

MG: The ethical and moral models set forth by the religions, you mean?

Soleri: Yes, and also the performing models of the norms which allow for the performance of anything. The thing which I find very funny, or not very funny, is that I always have to take those models and look at them this way because they are upside down as far as I'm concerned. So I have to take them and turn them over and then they begin to make sense.

MT: How so?

Soleri: Well, because my notion is that if I'm presented with a reality which originally was absolute and perfect then I have a terrible problem to make any sense, to give any meaning, to talk in any sense about the legitimacy or the justness of anything. If the beginning was perfect what's all this fuss about? Let's have the beginning.

MG: Could that be some type of model for ultimate spiritual reality, original spiritual reality, totally apart from the physical world that we're going back towards?

Soleri: That's a dualism I won't have time to deal with. The notion of the fall, spirit that made matter and then matter not being up to spirit, seems to me very arbitrary. I can explain the wanting nature of matter because evidently we're made of matter and we find that we are faulty. I would say it's lucky that matter is, because only through matter, I can be, no matter how faulty I might be. Why not try and find out, attempt to do in such a way as to make matter less faulty. By making it into spirit.

RR: Is it necessary to maintain the disorder or to let it destroy itself and hope that from those ashes something new surrounding the fifty acres would be engendered?

Soleri: I'm not endorsing the notion that I create order whatever the cost might be. I believe that those fifty acres belong to the surrounding acreage. In general things are happening in positive ways if the degree of complexity of the total system is improved; things are going badly if the degree of complexity of the total system is diminished. Now what was the total system? A good question. I think probably we could limit the total system to this planet just for the moment. And then suggest that if the intervention of me, you, the trees and everything else, is such as to increase the complexity of what we call the biosphere or noosphere or whatever, then we are on the road to better things. If all those interventions are going to be diminishing the total complexity, then we are on the road to disaster.

MT: How do you define complexity?

Soleri: In a way, the degree of liveliness that results from the interaction of the participant. Because I feel that complexity ultimately can be equated with what I might call "liveliness" or "consciousness" or "sensitization," and so on.

RR: Do you infer that all things should be obliged to participate?

Soleri: No, but they are participating. Obliged or not, it is inescapably participatory. Because there is enough interdependence and dependence to make sure that the system is ultimately one system.

TB: Do you think, Paolo, that there is no such thing as negative complexity?

Soleri: Yes, I tend to call that complication more than complexity.

TB: But in a sense, complexity is a process that goes on and on. This may be a simplistic kind of example, but modern technological complexity has brought us to the point of really polluting the biosphere, a form of complexity through human intervention in the material world. Do you see that as ultimately positive?

Soleri: I interpret that in a slightly different way, probably. I'm, let's say, the physiological and mental organism. And then I have a camera and all the equipment that I am working with. If with the addition of this complexity the end result is diminishing complexity, then I am in the presence of a negative process. It might well be that I am so addicted to the camera that I am not able to see without it. Well, at that point, I might be handicapped. My sensitivity and my ability to perceive and enjoy, to make something out of the environment, might be diminished.

TB: Do you see the augmentation of individual complexity as essential for the augmentation of societal complexity? For example, if we are all plugged into a computer terminal it might be very simplifying for the individual, but for society as a whole, very complexing. Or do you see the increase in individual complexity, spirituality and consciousness as absolutely essential for the increase of the whole society.

Soleri: I think the answer would be in exercising some kind of a very sharp analysis to find out what's happening and how it's happening. But I think ultimately that in order to have the greatest complexity, both the parts and the totality have to be at the maximum capacity of complexity. One thing that technology clearly does is simplify, break down the complex and then come out with complicated devices which are very effective in a very narrow range.

TB: So you would be in agreement with, say, the ecological movement that we should begin to look at the control of technology. We should begin to see technology as the major factor deteriorating the quality of life on the planet?

Pollution

Soleri: I would say that we are too nonchalant in always assuming that because we add a new technological tool we are going for greater complexity. We might well blind ourselves or take short cuts that, instead of

enriching the system, impoverish it. When I'm told, for instance, that I shouldn't build a dam because this little fish might be sacrificed then I have to think twice. I understand the danger of saying well today we sacrifice the little fish, tomorrow the little frog, and so on. Sacrifice by sacrifice until we find out we're alone, the only life form, having gone into the ultimate sacrifice one step at a time. But that should not hide the fact that that little fish may ultimately find his niche. I may push him aside for the moment; he may then go and do something else. Now that something else might be *per se* evil or might be *per se* ambiguous or might end up being very important.

TB: So, you don't see non-intervention in the environment as a solution to the ecological crisis?

Soleri: No, because if there's an earthquake and a mountain collapses, making itself into a dam, with the result being your lake over there, I have a hard time seeing that as a positive ecological or divine providential act while my building a dam somewhere else is an evil intrusion in the natural process. I put spirit where perhaps spirit is not, which is in the earthquake coming at a certain spot at a certain moment and developing into a certain alteration. So on one side I have the pretension that whatever happens in nature is right and it is almost balanced by the other pretense that almost anything we do is wrong.

RR: But nature has created the perfect environment, the result of which is man, the most perfect creature. Why try to alter that perfection?

Soleri: No, I don't buy that. We are what we are because there's been a sequence of processes which somehow one step at a time have defined man, but we could be a thousand times more perfect or a thousand times less perfect. I don't see any perfection in the processes of nature creating us.

RR: But how did we gain this ascent? Why change the environment? Why not keep the environment which has taken you from the trees to Arizona?

Soleri: By that exact reasoning the tree doesn't have the right to be there. Because before that tree was there, there was an earlier tree which was much more primitive; and before that primitive tree was there, another creature which was even more primitive, and all these creatures if they had a mind would say, "Hey, I'm in the image of god and nothing's going to change me because I'm in the image of god." So we de-escalate down to a moment when we find out there's only stone and water and fire. Even there we have to go back and we end up with hydrogen and the big bang and we say, "Well, this is the real stuff. All the rest is intrusion — it's pollution."

RR: But in that setting man proceeded up his own destiny. We certainly have progressed in the last million years in the right direction.

Soleri: Why then not accent that and say we are one of the steps in this ladder towards who knows what. If we are one intermediate step, then evidently to stay there is not only a mistake, it's a sin.

RR: But it is also quite threatening to change the factory that produced the perfect machine.

Soleri: Well, no, there is not a perfect machine.

RR: Not perfect enough?

Soleri: No.

MG: We already have changed, changed the machine. Our existing cities have already changed us.

RR: I've built things. I'm not pushing the big cities. I think if it went the other direction — of becoming little hamlets and little villages — that man might get to his next step in his chain more successfully. As you said, maybe with this high density, high technology, he's going to blow himself up. It certainly has indications.

Soleri: Yes, but the fact there exists a danger of pathology doesn't say we should remain what we have been.

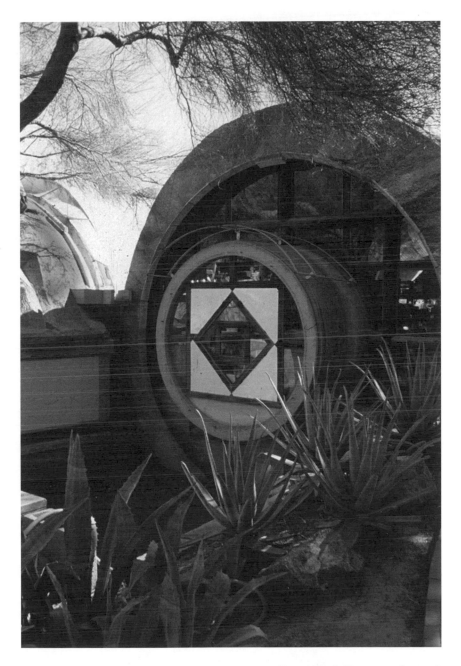

Barrel Vault Structure, Cosanti

RR: It's a conflict. Three hundred years ago there wasn't the conflict of east and west, so we didn't create the hydrogen bomb. Man seems to create what he needs for the moment and it seems to me that the more density, the more apprehension, the more fear, possibly the more destructive weaponry and so on.

Soleri: Yes, but again we can take it to extremes. We could say, Adam remarked to Eve, "We're the least densely populated form on the planet." Is that the ideal? Or is it one billion? Who knows? To connect directly the positive with density? The capacity for love with density, and so on.

Population

RR: But you seem to me, for the few moments we're here, to be sensitive, to be responsive, to be on a quest. Yet your setting is not Century City, your setting is not Chicago, your setting is here under your fig tree. A single man under a single tree.

Soleri: Well yes. But number one, what we're building there is slightly different from what we're building here. And what we're building here is not yet what we are seeking. So in a way my ideal is Chicago. It's not the fig tree and a chair under the fig tree. But I have reasons for believing that Chicago is closer to "God" than this chair under the fig tree. Not that the two are exclusive but there is definitely something that has to do with number, which has to do also with richness. And that's part of the complexity. What is complexity? More and more things using less and less media.

MG: That's a good general definition of complexity.

MT: That's basically the definition of stability in any ecosystem. A climax forest has reached that state of stability. It's very complex but it's of a higher order of stability than a preceding forest.

Soleri: Okay then, the next question would be: Is this forest the icon that we are to contemplate forever? Many billions of years from now is

the forest still a valid notion? Quite probably not. It wouldn't make any sense. We must watch so that we don't fossilize ourselves and the forest by saying there's nothing better than the forest. For the moment the forest is a tremendous asset and we should be very careful in getting rid of it, destroying it, not just for our own sake, but for the sake of reality in general. But we have to be very careful because by saying that the forest is an eternal datum that is sacred and cannot be altered, we are speaking bigotry.

MT: The forest never looks at itself and says, "I'm not going to be here in a million years, therefore I ought to work expeditiously to do something else."

Soleri: We know it's not going to be there anyhow.

MT: Well, we don't know that for sure. Even examining the record of vegetation in the past, there has always been — since 400 million years ago — some kind of land cover. It doesn't conform to the same rudiments as today's cover, but —

Soleri: What I mean is that, no matter what the past is telling us, that we know that in a certain span of time Earth is not going to be capable of supporting the forest because it's probably going to volatilize or be burned out or it's going to become a cold piece of stone. Whatever. So it's quite clear that if there is in us a notion of fundamental justness, then the notion has come out of the model which is not the model of the eternal forest.

MT: But then how sensible is it to orient one's life to a model which won't actually be applicable for many millennia? That's the other question.

The Absolute

Soleri: Because we are after eternity, we are after the absolute. That's why we're inventing religions. Why be religious if you don't need those

things? Forget it. Let's be nice good pagans enjoying life, having a ball and forgetting about it. *(laughter)*

MT: And terribly polytheistic as pagans. There was apparently in that free-for-all an even greater need of the absolute; it was invested in every object.

Soleri: Okay, then, if we seriously talk about the absolute, we should be serious about it. And to be serious about it is to accept the notion that Earth has a life span and beyond that lifespan there's no Earth. But there might be something else far more incredible than the Earth, no matter how incredible the Earth is.

TB: So within that allotted time span, presumably there is some process we have to reach and what do you see as that process?

Soleri: In very raw terms, that is the process of a reality that is becoming more and more complex, because by becoming more and more complex, it becomes more and more able to read itself, to understand itself, to develop anticipatory models that are more and more powerful in making prophecies, fulfillments, and so on.

TB: So the only hope for the Earth, as it were, is to get to the point where it can transcend the Earth itself once the Earth is destroyed.

Soleri: In absolute terms, yes. I don't see any possibility of straying away from that. But if we want to be practical, then we say, okay, let's forget about religion and absolutes and so on. There still is a difference between the practicality of the Western man and the realism that Western man could develop, even staying away from the notion of absolute.

TB: How does that absolute picture translate into present action, in terms of environmental questions?

Soleri: Again, in my simple-minded way, I find this paradigm of complexity an absolute paradigm, so no matter what the span of time is that would interest us, if we want to have a richer life we have to have more complex interdependence and inter-relationships and so on. This

will enable us to be more conscious of what surrounds us, what's inside of us, and how tremendously difficult it is to coordinate those things. I tend to believe that there's a triggering point where quantity becomes quality.

MT: What do you base that belief on?

Soleri: Not that I know what the brain or the cortex is, but I would say that there's no fundamental difference between the nervous system of a very primitive creature and my nervous system. The only difference is that the number of components, which determines the number of relationships and the number of responses, escalates in such a marvelous way that at a certain point that very simple action and response — whatever you call it — becomes thinking, becomes mind, and as it becomes mind becomes consciousness, and as it becomes consciousness, becomes responsibility, and so forth.

The City and the Cabin

MT: I have this image of Chicago in my mind, and of Saul Bellow in Chicago, and of wind, and of the Chicago Art Institute, and of all those wonderful parts of Chicago. And then I think of the south side of Chicago. You said that increasing complexity might enable us on a spiritual and biological level to grasp more essentially our surroundings, which I interpret as being not confined to the human surroundings. From the heart of Chicago, twenty stories up, with six inch separations between myself and my neighbor, what potential do I have for enhancing the spiritual complexity with the outside environment? How do you perceive that division which has reigned for all time between ourselves and our surroundings?

Soleri: Probably, in order to have a discourse going on, we should say that this is one occasion and that's another occasion. So let's make a comparison. On one side, we are living twenty stories up in Chicago and on the other side we have the person in the forest living in the log

cabin. I would propose that of the two realities, the reality of Chicago is not only more pregnant, but it's more productive in spirit or mind. Not necessarily because the individual living in that apartment is more intelligent than the person living in the cabin, but because the person living in the apartment presumes a network of things which is *per se* a premonition of the appearance of a new kind of animal. It might well be that the person in the apartment might not be very intelligent, but the neighbor might be more complex, let's say. But for me the person living in the cabin is handicapped because, fundamentally, the social and cultural foundations are very primitive and they might also be non-existent. I have to assume for this comparison that the person in the cabin is not living there while being plugged in to Chicago, but rather is there because Chicago doesn't exist. So since Chicago doesn't exist, nothing exists of the technology that might help this person. He doesn't have books, because books were not invented. He doesn't have language, because maybe language has not been invented if he was isolated. He just has ways of building a fire and contemplating it.

MT: And yet, the predominate proportion of our species has been and is agricultural, living out there in a cabin, living in a very frail concatenation of community farms.

Soleri: Yes, but they are tied to larger communities which, in turn, are tied to still a larger community. It's not the history of the cabin. It's the history of the cabin which is plugged to the community, which is plugged to the village, which is plugged to the town, which is plugged to the city. So it's nice, as a Chicagoan, to get away from Chicago because I've the means of getting away from the drudgery of it, but carry with me the advantages of it. So I have the radio connection, the television connection, the book connection, the telephone connection, the watch, the shirt, glasses, and I have all those things that have been given to me, not by the cabin phenomenon. It's a phenomenon which has the cabin phenomenon within it.

Complexity and the Urban Effect

MT: What is your principal motivation for pursuing the city of the future? Is it based upon your awareness of population problems or population reorganization needs, or is it really your quest for a greater complexity, representative of the human spirit?

Soleri: The need of the Urban Effect is not generated by the constriction of space, or the fact that the planet is too small, or that we are too many. That's only just happened recently, and now we have those responsibilities. The Urban Effect is positive by itself. It doesn't need the justification of the limitations the Earth is presenting us with.

MT: What are its justifications?

Soleri: The justification is that complexity, is, *per se,* divinity.

MG: Greater complexity, greater perfection.

Soleri: Yes.

MG: It seems these limitations on the planet are going to bring people to some of the conclusions that arcology is suggesting.

Soleri: Yes, I believe so. I wish I could make it a little more forceful, but I think that's it.

MT: Complexity as that totality of interactions between human beings in greater and greater density.

Soleri: Yes. But in order to make sense out of it, I have to start at the very beginning. Let's say there are two particles which are hitting each other, but they are somehow so hermetic that they cannot communicate. They just hit each other. Then I say it's a complicated affair, but it doesn't trigger anything. Then a little window opens in one and another little window opens in the other and they see each other, and talk to each other. Then you have a triggering of a complex process. So already, there is an intimation that something more is there than just hitting each other.

MT: But they level off. Every species levels off, every community levels off in the amount of absorption of energy that it can receive. It can't keep increasing indefinitely.

Soleri: But evolution contradicts that in a way, since at the beginning there were those few little agitations that were not much more than physical, mineral agitations. And now we're people agitating in tremendous ways. And agitation becomes animation at a certain point. I think, again, because of the summing up of so many events going on in the same amount of matter that at a certain point the "shaking" becomes mind.

The Aesthetic World

MT: Every one of us here — by the Willy Brandt report findings — consumes 1042 times more, per capita, than every Nepalese. This degree of redundancy which we demonstrate seems to me to be inefficient. When we speak of necessity in our life, things that we as human beings need, I'm reminded of the doorknob and of the bed which have not changed — size-wise — in thousands of years. Apparently, it's a practical and efficient size that relates to the human being in an intimate way. So I'm asking you, is there not a whole range of intimate requirements which need no more complexity?

Soleri: Yes. You see, if you demonstrate to me that you could have the Lucretiuses and the Thoreaus and the Einsteins and the Beethovens and the Stravinskys, etc., without this association and this cooperation, without this social nexus and this cultural nexus, then I would say, "Maybe the cabin is the answer!" But you wouldn't be able to demonstrate this. Thus the fact that a Western mode of living consumes a hundred-whatever-thousands more than other modes of living doesn't *as yet* tell me that this Western mode is more wasteful. I have to see the results. And again, I might be very parochial, but if I have to choose between what the West has given to me and what the Nepalese have

given to me — have given to mankind — I would have to choose the West. The reason is that the West has given me Beethoven and a few of those other guys.

MT: So, for those momentary zeniths . . .

Soleri: Ah! Those are not momentary. If there is anything that is everlasting and an absolute in many ways, it is the spirit exuding from those zeniths.

MT: And the trade-off?

Soleri: Economy. I think the epitome of economy is not to be found in what we call the economic world. It is to be found in the aesthetic world, where a very tiny amount of energy, a very tiny amount of material, does very powerful things. By the way, did you see Tristan and Isolde last night on television.

ER: No, I didn't see it.

Soleri: This incredible singer played Isolde. She was marvelous. I have seen her before, but in this part she was . . . ahhh! That's when you feel that it's all worth it. It's worthy being alive.

MT: What is your greater urgency at Arcosanti? Is it the aesthetic pedestal or is it a form of rational survival?

Soleri: I always believe that the two are working together. But, just for thinking, you say, well, if I cannot do the most, let's see if I can do the least and the least would be to offer alternatives that might be more useful to life. And one of the usefulnesses is to be less encroaching on the other kinds of life which are around.

MT: So lesser intervention does play an important role at Arcosanti.

Soleri: Yes. Not because I don't believe in intervention, because anything that exists, any organism, is an intervention in something which existed before the organism. But because I think we are still quite un-

117

able to really come out with a realistic response to the historical and contextual moment. If I were superintelligent, superwise, and superloving, I would say, well, I feel that I can intervene much more substantially. But since I am not any of those, I have to be prudent.

Arcosanti

MT: What are some of the basic tenets of Arcosanti which are "lesser interventionist?"

Soleri: The size itself. The idea that by reducing the bulk of something you might be able to see that the sum of everything, including the ecological system, is better served.

The fact that since we are not pure spirit, we depend constantly on gravity laws, thermodynamic laws, time and space constraints; therefore, again the notion is that the complex is utterly connected with size, which is miniaturization.

The fact that perhaps we can do better with existing energies, mainly solar energy in this case, to help us to take care of our needs.

The fact that in some areas of the globe, water is scarce, so becomes precious, so we should try to pattern our habitat in ways which are saving and make better use of water.

And then the one which I think is in many ways the résumé of all of the other ones, that things tend to segregate themselves, in many ways because they had to, because they are not good at not being segregated.

MT: That last point, again?

Soleri: I stand for segregation in the sense that I have to isolate my flesh from your flesh and from what surrounds me in order to exist. This segregation gives me not only autonomy but makes me real. If I take a knife and split myself in little slices and say now I am connected, well, sure, that which composed my body is more directly in touch with other

bodies, but I no longer exist. So I have to segregate those elements in a way to exist. But then if that gives me justification for applying this notion of limiting and separating and dividing to other contexts, I find out I'm undoing what I'm probably here to do — which is to synthesize and get things together instead of separating and splitting things apart. So as an autonomous creature, I need to exist with other autonomous creatures. Constant connection — that's the Urban Effect.

MT: Is there some optimal density of population that would be standard throughout the world?

Soleri: I think that probably doesn't work in space-time parameters and doesn't work historically. Each context has its own answer. On the planet now there are all sorts of optimal conditions for different kinds of contexts.

MT: Are those conditions determined by the environmental constraints? Or are there other determinants?

Soleri: Only in part environmental. Then also social, political, economic, technological, psychological, religious, philosophical. They all play an important role.

The Bomb

MT: You have spoken of quantity as somehow indicative of a higher and necessary complexity. I think of the dinosaur's size and its ultimate extinction and the obvious analogies to the A-bomb and nuclear weaponry. How do we redefine that advent so as to remain optimistic in this whole progression to which you've been referring? Your own descriptions suggest a necessary logic for the development of the A-bomb, and there are those around us who govern us, who insist on the logic. But according to your scheme, it seems to me that that is such an obviously suicidal course for the survival of all of these Beethovens and human interactions that we're seeking. Something went awry.

Soleri: Yes, but I keep telling people who work with me — to perhaps a nauseating degree — that inequity is ingrained in reality and is particularly ingrained in human reality. So the atomic notion, in terms of the use we are planning to make, is evidently clear evidence of the inequity that is built into ourselves. In the case of atomic war, it is an inequity which develops out of fear and bigotry, again, intolerance, the notion that part of the human species maybe knows what goodness is but says "No, I'm not going to use it. I'm going to be something else."

MT: How do we reorient perception? Given that it accumulates from the various components — the religious, the sociological, the psychological, the ecological, the aesthetic. They combine to create this dependency, this paranoia.

Soleri: That's where the responsibility of the person comes in, and the importance of the person. I have to see if I am very coherent when I decide that it's better for you to be dead than for me to be red, for instance.

MT: This takes us full circle. I see you here contemplatively under your tree and I think that the individual to whom you now refer is the ultimate salvation in terms of being responsible.

Soleri: But the individual becomes a universal person, it doesn't remain just a little creature under a tree. He or she becomes universal enough to understand that even though I have my preferences, those preferences have to be within the boundaries of the preferences of the species. And the preference of the species is not self-destruction.

Chicago/Arcosanti

MT: Can you graft your lovely structure out in Cordes Junction, Arizona to a Chicago, or does it have to start from a beginning?

Soleri: That's like comparing a virus to a fish. Chicago is far more com-

plex than Arcosanti. It also happens to be more complicated.

MT: But how can the ideas of Arcosanti become applicable to Chicago?

Soleri: That's where the laboratory notion comes in. You start in a simplified way. You are trying to take the village idea and make it into more of an urban condition. If you are able to trigger that kind of transcendence, or a little quantum jump, then you can go to Chicago and say, "What about trying to apply these notions and see what happens?"

TB: Arcosanti can become this little virus and begin to penetrate other cells and start reproducing itself.

MT: William Burroughs has used that idea in *Naked Lunch*. He speaks of "the word virus" — a single word with the proportions of God, the gravity of God — which, within 24 hours has infected every speaker on Earth. We all know, for example, how fast a joke or pheromone gets passed around. Nervous impulses in *homo sapiens* travel 224 miles per hour.

I'm not at all disposed to this "virus technology." I feel it is imperative to investigate pre-virus humanity, before it has been usurped. There are still some tribes throughout the Trans-Himalaya or the Amazon, for example, where there have not been many migrations over the last 5,000 years. And yet today, as we probe into cultures that reside there, we find remarkable insights in their agricultural techniques, marvelous handicrafts and a whole host of other human, specifically human activities which are incomparable. Amazon Indians can lavish on their verb tenses greater expressiveness — call it complexity — than Plato, Truman, Mozart. A human being with sensitivity and artistry is producing something which has integrity about it in the heart of the Amazon. The point there is the old Socratic argument that we've been touching on throughout our conversation: The person seated under the olive tree — do we really know anything about him? Is his gift to fellow people as relevant, as fiery, as vital, as your poet in the upper east sixties of Manhattan, with the constant onrush of sensation. Or what of the Ti-

betan poet vs. the atomic physicist?

Soleri: I think that if we contrapose that group to this group, we should not just talk about the poetry of both of them. We should talk about what they have been "producing." As soon as we look at the bulk of "production," I would say that it's very interesting that somebody in Tibet is somehow talking to us in the same vein as the particle physicist. As soon as I begin to look at the power and the bulk and the number of things that Western science has been giving us, I cannot see anything comparable. And music is the same.

MT: How much of that riotous science are we using? Let's be specific about Arcosanti. You have at your disposal hundreds of alloys, hundreds of possibilities for construction material, but you use a very basic, simple one.

Soleri: But when I am through with casting concrete, I go home and open a book and read about the Gaia hypothesis, I read about Prigogine and think about that, and Einstein and Fermi. It's an incredible, gigantic manifestation of mind.

MT: You don't think it was like that 5,000 years ago?

Soleri: No. Picking up that blade of grass and investigating the universe which is in that blade of grass and beginning to develop notions about the nature of it and how it's there and how it develops, how it was conceived, how I was born . . . Those things are enormously exciting.

TB: So you see that as more powerful, than, say, Blake simply seeing the world in a grain of sand. He's saying the truth, but what you seem to be stressing is the investigation of why that's true.

Technology and Survival

Soleri: The reason is that ultimately I believe that anything that becomes known and any technology that we develop is for the sake of the spirit,

because technology is going to give us the means to manipulate and transform reality. So the power that science is giving us, which we are misusing most of the time, is still a gift of such dimension that we should be constantly astonished.

MT: To believe in technology is fine, in my opinion, but when confronted with technology, how many human beings can utilize it knowingly? What do we really do with our technology as individuals?

Soleri: I think the fundamental thing there is that we are overwhelmed for the moment by what we invent, and we have to get used to it. We are not geared up to it yet.

ER: We really are at a point right now where, with such a rate of technological progress, it seems that man is going to have to adapt and find what's really useful.

Soleri: Yes, and my notion is that the more we get into this power of technology, the more we should become wiser and more knowledgeable and compassionate. That is why I always need to connect that with the environmental. This is the reason I believe habitat is so important, because it gives us the pedestal for the environmental learning process, which is almost the opposite of the learning process which is given to us by science and technology.

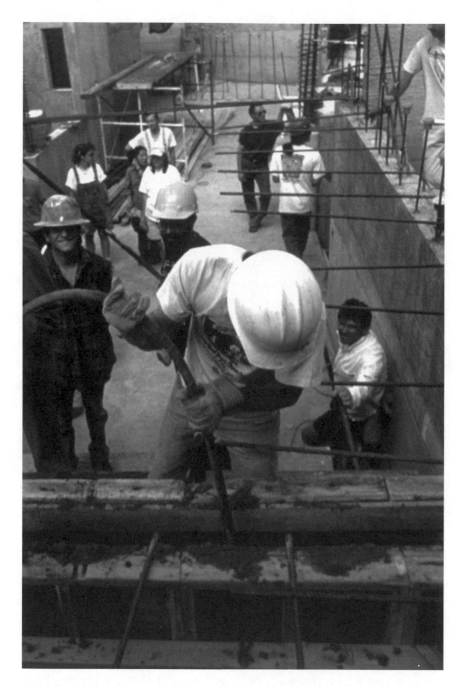

Construction at Arcosanti

Arcologies: Updating the Prognosis

"Most of the present environmental efforts are patch-up jobs. Increasing car mileage and recycling are important, but they don't touch the core issue. The source of our problems is that we've given ourselves the wrong pattern to build upon."

In March 1991, *Progressive Architecture* published this brief conversation between editor Philip Arcidi and Soleri. Here the environmental crisis moves closer to the center of Soleri's rationale for the development of urban laboratories.

<div align="center">* * * *</div>

While suburbia has grown exponentially, Arcosanti remains largely unbuilt. Undaunted, Soleri stands by the vision he first proposed a quarter-century ago. Visitors to Arcosanti, outside Phoenix, find a small, not-so-young community, and the first pieces of a stratified city in the otherwise untouched landscape. Paolo Soleri continues to adapt — but not compromise — his scheme. *Progressive Architecture* editor Philip Arcidi interviewed him last year. Excerpts follow.

PA: How would you describe the state of architecture today?

Soleri: The main failure is a myopia. . . . We are groping; our priorities are upside down and we get trapped by things. Counter to current trends, I insist on a paradigm of complexity and miniaturization, because that is what every living thing is made of. If we looked at some of the basic tenets of life as revealed in biology and evolution, then as architects we could address problems that surround us today. It would tell us why suburbia is catastrophic. We cannot keep building tiny little

limbs scattered all over the planet without connections. We know that in biology a system is viable because it is rich in interwoven, cooperative subsystems. We're very good at making fingernails or toes or ears, and sometimes these turn out very beautiful. But if there's no conception of the animal itself, those things become quite irrelevant, like an appendix.

PA: How do you envision the stages of realization of an arcology? Can it emerge incrementally?

Soleri: To recognize the importance of environmental concerns was a great first step. We ought to realize that life is more difficult and harsh than we would like to believe. Basically, nature doesn't care about us. This idea that there is a benevolence in nature is misleading. An arcology encompasses a change of mind and attitude — a realization that the way we live now is probably not sustainable and perhaps not ethical.

PA: You wrote that "function follows form."

Soleri: Here I presented two things, but many people picked up only one of them. Nature seems to generate functions that follow form. We humans, with our intelligence, tend to do the opposite: We have a set of needs and we attempt to respond to them by coming up with a form. But I would challenge anyone to tell me that they design solely with the proposition that "form follows function." In fact, we all work with archetypal notions from the back of our minds. We need to design with a balance of the two approaches.

PA: In your sketchbooks, humanity's construction is always distinct from the landscape. On the other hand, some architects describe humanity and nature as convergent.

Soleri: We shouldn't disguise our presence on the earth. It's pointless to say that we shouldn't interfere with nature. We are interfering with nature anyway because we are consumers. Many of the greatest things mankind has made are a deliberate presence on the natural realm; they're not fuzzy little things.

To turn to the issue of megastructures: You know, I intend to build something that is physically a "mini," not a "mega." The city of Phoenix is truly a megastructure. I suggest that something as sprawling as Phoenix could instead be made of ministructures. If they happen to be more visible in the landscape because they're tall and stratified, that doesn't change the fact that they occupy only a fraction of the volume or consume a fraction of the energy used in Phoenix.

PA: What are some of the lessons that Arcosanti has taught you over the past twenty years?

Soleri: In general, I've learned that the human animal is a very strange animal. Secondly, I can't ignore the challenges of working at Arcosanti. Here, where work and life are one, you can't put one aside for the other. In many ways the people who are working here are heroes; they're coping with a small and isolated setting. We can't easily go to a great urban setting for a respite. If we had a better flow of money it would solve many of the problems we have. We'd be able to separate the construction process from living.

Now we are again in the middle of a storm because of the environmental crisis. But today no one mentions that our energy problems are largely caused by suburban sprawl. Nobody even hints that this piece of the American Dream is going to pieces. No matter how well we do the wrong things, we aren't going to solve the problem. We'll simply cushion it. The way we have apportioned the landscape in this country is, by definition, the most wasteful way it could be done. We're stuck with it in the present system, and it's going to be very difficult to get out of it. Most of the present environmental efforts are patch-up jobs: Increasing car mileage and recycling are important, but they don't touch the core issue. The source of our problems is that we've given ourselves the wrong pattern to build upon. The wrong pattern is the suburban pattern. And the American Dream is unnecessarily chained to it.

Citizens of the Cosmos

"Our skill to manipulate things is not matched by the wisdom that we need to manipulate so many things. So we over-reach in terms of production and consumption, and we are underachievers in terms of knowledge and wisdom. The price to pay is very high."

On November 30, 2000, Jeffrey Cook, Regents Professor in the College of Architecture and Environmental Design at Arizona State University, interviewed Soleri before an audience at the Scottsdale Library. In this conversation, Soleri introduced his notion of man's place within a reality of cosmic proportions, and the implications of this idea for decisions we make not only in urban development, but in daily life.

* * * *

JC: Paolo Soleri is a Scottsdale resident who has been familiar with this valley for over fifty years. Paolo first came to this area in 1947 as an apprentice to Frank Lloyd Wright at Taliesin West. After that experience and building his first house, the very interesting and important Dome House in Cave Creek, he moved back to Italy with his new bride and spent five years in Italy establishing himself as an architect. There he built a major architectural work: a ceramics factory on the Amalfi coast. In 1955 he returned to the U.S., and in 1956 he settled on five acres in what is now the incorporated town of Paradise Valley. Paolo still lives in the little, pink, wood house at 6433 Doubletree Road. From there he has become known globally as an urban visionary and the originator of the concept of "arcology," a word that fuses architecture and ecology.

In 1970 he began to build the smallest of his arcology designs called "Arcosanti" at Cordes Junction, an hour and a half north of Scottsdale.

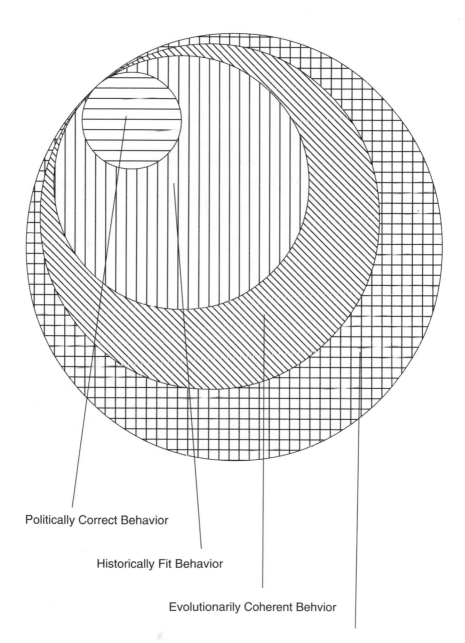

Politically Correct Behavior

Historically Fit Behavior

Evolutionarily Coherent Behvior

Cosmically Relevant Behavior

In the thirty years since, he has had the opportunity to understand better the dimensions of his vision, to watch its evolution, and to observe what has happened locally and around the world. It's an exceptional opportunity to have present in our community someone with these extraordinary experiences and insights: Paolo Soleri.

Soleri: Usually I have three hundred slides but I will be frugal. I'm presenting this single slide — the Bubble Diagram — at the beginning because I have a way of thinking that you might not consider normal. This diagram suggests another way to position ourselves within reality. There are four bubbles: The largest, the Cosmic Relevance bubble, is as big as the cosmos to date. The next, the Evolutionary Coherence bubble, is the summation of all biospheres peppering the cosmos up to date. The Historical Fitness bubble is as big as the summation of human history, and the smallest, the Political Correctness bubble, is as big as the U.S. today.

The largest is the Cosmic Bubble. The one inside is the Evolutionary Coherence bubble, which is tiny-tiny compared to the Cosmic Bubble. So in the diagram there is no scale involved. On the cosmic scale, the Evolutionary Bubble is invisible. Then this Evolutionary Bubble surrounds the Historical Fitness Bubble, which is the reality that we have been building as humans on this planet. Inside this Historical Bubble there is a smaller bubble that I call the Political Correctness Bubble, which is the here and now as we conceive it, as we live it, and as we build it.

The point I'm making is that, depending on where we put ourselves, we might come up with different notions about things and how to behave. In the present, most of the time we act as political animals, and we like to be correct. That involves a number of limitations, because in order to be correct we have to compromise constantly, and we do, day after day. If we stay with that kind of perspective, our lives and our behavior take a certain form, a certain shape with certain values. If now and then we try to look further than that and to see ourselves as historical beings, then our perspectives can be altered somehow, so that

things that are correct there, might not be meaningful here. That means we are beginning to open up our lives to what happened not only yesterday, but the day before yesterday. The American people, for instance, have two hundred or so years of history. But then those two bubbles are within the biosphere so that suggests the biosphere.

Once we are able to perforate, to penetrate, or even to look through to the Evolutionary Bubble, we are surprised that our biosphere, which we see as very important, and indeed vital, is virtually invisible. We come from our biosphere, so unfortunately if we fail to recognize this presence, we will fail, and that's one of the problems we have. If now we can reach even beyond the Evolutionary Bubble, then be presented with something that we can hardly understand, that we can hardly conceive, we see that we are stardust. So we really come from there, and we are there, and that's inescapable.

By the way, all the bubbles have one point in common, which is the present. And depending on where we position ourselves even in the present, we have different perspectives. So what we are doing in the inner two bubbles might be insignificant. But if we want to become significant for ourselves, eventually we have to cope in this outside bubble, Cosmic Relevance. Again, that's inescapable.

To repeat this premise, the Politically Correct Bubble is as big as the U.S. today. The Historical Fitness Bubble is as big as the summation of human history. The Evolutionary Bubble is as big as the summation of all biospheres peppering the cosmos to date. And the Cosmic Bubble is as large as science and our imaginations can conceive the cosmos today.

JC: If I could characterize one of the aspects of Paolo's reputation, it has been his ability to enlarge our frames of reference. So I'd like to raise the question about how we, in this community, can embrace these larger frames of reference. Especially when we live in a new community like Scottsdale which has so little history, which has so little in terms of roots. In fact, the whole purpose of this lecture series is to search for those roots.

Soleri: We can face reality in two ways. One is being practical and the other is being realistic. There are enormous differences between the two, and naturally, since we live in the present, we say we are to be practical or else. The fact is that quite often the practical is the wrong thing. Since we have lessons coming from all sorts of domains, now and then we should try to look beyond the practical and become realistic. That diagram points out that realism is not Political Correctness. It's far more telling and demanding than that. So if we face our problems personally, then as a society we may end up pursuing things which are really, really damaging ultimately. And ultimately, at the present, this is not a hundred years from now, it is next year. One example is what we do with our land, and how we cope with the gridlock that we are moving into. Within that frame of reference, I think that one of the most telling and possibly damaging things that we are dealing with now is what I call hyper-consumption. We're all in it, and I think we're all victimized by it. It would take many hours to go through a list of things that show how our practicality might be extremely pernicious in many, many ways.

JC: Do you see any difference in how the folks in Scottsdale are practical versus the folks in Phoenix, or the folks in Cincinnati?

Soleri: Not really. The reason is that we are developed as a society, as a nation, with fulfillment by materialism or hyper-consumption. So as long as this is the connection, we are going to face terrible problems. We are facing them now. The solution isn't going to be tomorrow, or the day after tomorrow. It's going to be a long, long process of undoing a number of things and slowly moving, possibly in a direction that is not the direction we are going now, even if we remain within the boundary of this continent. If we open up to all countries, then we find there is a terrible question of equity that we are not facing at all, and that's going to come back to us eventually.

JC: But we don't have control. Those of us in this room certainly don't have control of the whole continent. Some of us even have a lot of difficulty getting ourselves from day to day. What directions should a com-

munity like Scottsdale take, what responsibilities can they shoulder against this, your first bubble embracing the whole American way of life?

Soleri: We are dealing with problems that are very fundamental, and there are no quick fix solutions. They are not available. In a way we have been making mistakes for many generations, and it will take many generations to undo the mistakes, if we are willing. The price is very high for people in the habit of believing that in order to be good citizens, we have to be good producers and good consumers. The whole structure of what we're doing physically and non-physically reflects this dedication to what I call hyper-consumption. The sprawl that we are battling is a sprawl caused by acceptance of this hyper-consumption. The single home is quite evidently the most expensive, the most pollutant, the most wasteful, and the most segregational thing we have ever done in our lives. So I don't think there is an answer to what we are battling now. Eventually we must alter our priorities, and then go from there. It will be pretty hard.

JC: You're not very optimistic.

Soleri: Nope. Not in short terms; in long terms, yes.

JC: I guess I'm curious whether you see some differences between communities, especially on a regional basis and perhaps from a climatic point of view. Or maybe in terms of size. I'm not looking for any flattery for Scottsdale, but how do you see Scottsdale in relationship to the American pot?

Soleri: Scottsdale, being a very young experiment, has all the virtues and all the non-virtues of being very young: inexperience, quite a bit of drive, enthusiasm, and the ability to make terrible mistakes. Often the mistakes are from the mentor. Moving from an existence of scarcity to an existence of super abundance, as we know it, throughout history, means that by having gained so much, we slowly seem to be losing very much in other directions. Thus, directions of self-responsibility, the

direction of trying to connect yourself with larger and larger sectors of reality, including the territorial reality, are slipping. Then there is the fact that we are manipulators of things. We are very good with our hands. So when we combine our hands, our larynx, communication, and this wonderful thing in our skull, we come off as *homo faber*, the Maker, and we are still *homo faber* more than *homo sapiens* in a way. Our skill to manipulate things is not matched by the wisdom that we need to manipulate so many things. So we over-reach in terms of production and consumption, and we are underachievers in terms of knowledge and wisdom. The price to pay is very high.

JC: But looking at Scottsdale as an adolescent community without hardening of the arteries, isn't there the possibility of positive experimentation, as well as the possibility of making larger mistakes than other older communities. Isn't this an evolutionary possibility?

Soleri: I think that entails a certain basic agreement about things. We tend to think two-dimensionally and there are reasons for that. We like the notion of being free and having a little domain to control, including contact with nature and a few other things, most of which are romantic and nostalgic because they're unreachable. We're destroying that which we seek by how we behave.

Take the car, for example. As long as we think in terms of two-dimensional development of habitat, quite definitely we are making our present problems. That's a universal fact. We should be aware that we are dealing with thermodynamics, with gravity, and that there is a price for moving things, and it is not going to go away. Unfortunately we chose a technology, the automobile, which is enormously gigantic and very expensive.

To try to improve that situation I think is to try to improve what I call "wrongness." The more that we improve wrongness, the more we get to the wrong side of the street. So this battle of how to control our spreading out, how to subdivide the land so that it might make sense, has an element that is very protective. The more we get attached to this notion of having a home, which is continuously enlarging, becoming

bigger and bigger, the more the demands are made from the productive side to fill it and make it comfortable. The more we do that, the more we need all the utilities and all the easements that development requires. So we are developing what I call a planetary hermitage where we become hermits within our small domain.

Then we say we can handle all that because we can communicate through the Internet, for instance. But we cannot eat on the Internet, we cannot get water from the Internet. We cannot do anything that is not virtual on the Internet, besides informing ourselves. So the real problem is that we do not want to accept the notion that a single home might be our nemesis.

JC: You discuss Phoenix as a sort of prototypical American situation of extended suburb. I wonder if you have any thoughts about rural life, especially since you once experienced Scottsdale as few of us have, when it was just a crossroads. That's an enormous transition in the fifty years of your experience. Aren't we now operating in a very nostalgic way about what was once viable?

Soleri: Yes, it's very natural for a population that has a whole planet available with lots of promises and lots of space to decide that, since I like that little valley over there, I'm going to colonize it. But there are a thousand people or a million people who want to colonize the same little valley. So this is a development that is almost unerasable. We don't know what to do, how to behave so that this process might be slowed down and altered, and maybe reversed. But that's the human condition. At a certain point, we might have to decide that we cannot say, "I do what I please." We might have to say, "I should do what maybe I ought to do."

But we are not there now. Democracy doesn't allow us to talk in those terms. So the "Do-as-I-please," which is sometimes more a license than freedom, makes us act out our lives in ways which ultimately we find out are not livable. We are moving into that kind of situation, and we've been moving in that direction for at least two generations, since the Second World War. Nature is telling us that we are moving in the wrong direction.

Arcosanti is not a flat land. It is a three-dimensional system, and the reasons for this are very simple. Information and knowledge come from clustering, and if we don't cluster there is no life. The brain is a very good example. The brain exists as such a fantastic engine or machine because it's so minimal, so tiny, so complex, and that's where life is. Some might not like it, but clustering is where life is. So countering this a colossal mistake.

JC: In your travels around the world you've been exposed to lots of other countries and cultures, many of whom regard the American way of life as being their goal. But I wonder whether you haven't been exposed to cultures that have other goals which you would find more acceptable, especially within your understanding of the bubbles as you began.

Soleri: It seems to be in our nature as humans to seek some kind of transcendence. We transcend most of the time in tiny little steps, but that's very important. The pulse and desire and the drive are there. We might have to give in to this need to go beyond what we are, toward what seems to be the nature of things. This stepping up into another kind of reality in many ways depends so much on how we work out our problems and our tendencies in terms of domain and control — this notion of freedom we cherish so much. Most of the time this takes us to extremes which are not possible.

Let's take a physical condition. I was flying above China and for many hundreds of miles you could see the sustainable villages were very integrated and very lively and very admirable in many ways. Around each village there was farmland. So the villages were distributed very geometrically. Within that kind of an economy, if the people in those villages get automobiles and take off in the direction of the Los Angeles mode, each village would become probably ten times as large as they are now. That means that all the land for food production is gone, all of it. In United States terms, that would be a step toward affluence and well-being. Well, here that would be the opposite, that would

be catastrophe.

So to exploit the American Dream is something that I don't think is either feasible or desirable. But that's what everybody wants to do. In China, in India, in Africa, in South America, everybody wants to get to a point where they can say, "I feel like a good citizen, like an American citizen." But that is catastrophe. The Chinese — 1200 million — would need about 600 million automobiles. Six hundred million there, 500 million in India, 500 million in Africa, and 600 million in South America, and then Europe and U.S.; so we become the victims of our own beloved automobile.

JC: So do you have an estimate of how many Earths it would take to support our present 6 billion people in an American lifestyle.

Soleri: The number has changed depending on the perspective. Let me go from 10 to 40. Ten planets could do it maybe. But evidently we could not colonize the equivalent of ten planets within one or two generations, it might take a hundred generations. So there is a wall there that we cannot break. Somehow we have to alter our priorities and maybe find what we call happiness in an environment that is not the one that we are trying to develop now.

JC: How is this related to Arcosanti?

Soleri: You have to be in the middle of the mistake to try to do something about it. What I'm trying to do is to exemplify what I am talking about. Arcosanti is a very modest, limited, insufficient way, but we are working at it. We have thirty years of experience at what I call a lean economy. What I am proposing is an alternative to what we are doing now as Americans and as Europeans and, eventually, as earthlings. This alternative is to implode the habitat, adopt a three-dimensional model so that we put boundaries in our physical presence, and create within those boundaries a fairly lively, what I call "Urban Effect." This is not a new concept; it's old, about 10,000 years or so. But now with the technological revolution, with scientific knowledge and with the popula-

tion explosion, we are at a point where this is no longer something that we might have to face a few generations from now. Now is the time to face it or else.

JC: So in your thirty years of experimentation at Arcosanti, what have you learned?

Soleri: A few things. Small communities are very difficult.

JC: Well, so are big ones.

Soleri: But the reality is, if there's a desert around me or a forest around me, and if I build a town that is four hundred square miles, inevitably I'm isolated from nature. Nature is no longer part of my life. That's what we're doing with the suburban and ex-urban sprawl. We are isolating ourselves from nature. And why? Because we love nature and we want to be in the middle of nature — this is the paradox that we're developing, that we are believing in, and I think that's a very delusional situation. If we really want to enjoy nature, we should collect ourselves as any natural living system does, and then have this contrast, and this ambivalence, and this beautiful experience of being an urban person, and being also a country person. Sprawl instantly and naturally destroys this ideal.

JC: How did your experience at Taliesin as a young man shape your thinking?

Soleri: It was very important and very enjoyable, but from there on I began to diverge from the Broadacre City idea of Mr. Wright. I think Broadacre City is an example of something wrong that gets wronger and wronger. After World War II there was the Levittown phenomena, which was very visible and in many ways meaningful. But Levittown was very dreary and not very appealing. One thing Mr. Wright was great at doing was making this Levittown model into a very glamorous process through his own genius in architecture, housing, and so on. So I think this is an example where geniality and knowledge might help the wrongdoing to become even wronger.

The automobile was a great instrument for Mr. Wright and still is a great instrument for every one of us. But there was almost a magic to it for Mr. Wright. He always had the best. And that was natural. The automobile was a recent invention so all of us thought this was a solution to our logistical problems. So we plunged into that kind of solution and we got Los Angeles, Phoenix, and everything else.

JC: There's been the observation that Phoenix, the Valley of the Sun, is sort of the realization, however crude, of Frank Lloyd Wright's Broadacre City. A road every mile, a car in every garage.

Soleri: Two cars, and bigger and bigger. So we put ourselves in a very critical position. There is no way that we can alter that in one generation. But we should begin to think in terms of moving away from this identification of the good life with a hyper-consumptive life. I don't think that has very much of a future.

JC: What, then, is your favorite form of transportation?

Soleri: The bicycle. We are bipeds, we are pedestrians. For instance, the question of obesity and the question of not wanting to use our legs is a very clear problem. So you go into a building and instead of exercising your legs on the stairs for one or two or five floors, you take the elevator. Then we go to a spa to get back some of the flexibility and some of the grace that we might carry with us.

JC: What discoveries have you made at Arcosanti, especially about the idea of urban living versus access to nature?

Soleri: Access to nature is something I insist on. When I say that we should limit and contain our presence, that means three-dimensionally. And the reduction of the consumptive drift. At Arcosanti that's easy because we are so small that we don't have to take the car to go from one side of the city to the next. From my unit I can reach in a few seconds everything that is there: a café, the library, the ceramics, the foundry, the theater, the coffee shop, the bakery, the friends. So it's a question, for instance, of ten seconds, twenty seconds, sixty seconds,

that's all. But that's a pattern that is very easy for us because we are so small, but it's a pattern that has validity for any kind of size.

JC: Simultaneously you do have access to pristine nature.

Soleri: That's what I mean. We are on the edge between the urban image and very primitive nature — in this case, the wilderness and the canyon. It challenges the ideal of having so much greenery in the habitat. Some of the most beautiful experiences in Europe are in places where there is not one tree. It's just a presence of man in terms of architecture. That's how we filter nature and express it in aesthetic form. So I have more sympathy for limiting the size of our intervention and letting nature explode on the edge of it. That way we have a very clear definition of what we are and what nature is.

JC: What about the necessity of the preservation of wilderness for our own survival.

Soleri: We know that eventually the sun is going to give up. And when the sun gives up, if the biosphere is still here the biosphere is gone. Not instantly, but within some generations of life. So what we have now is a gift of immense proportion that should be respected. We should be the caretakers. Being caretakers, accepting the notion of stewardship, is half of what reality asks from us. The other half is creation. We cannot say that since the status quo now is what it is, it should be there forever. It's not going to happen that way. So in the long run, the memory of this beautiful process that has been the biosphere, which is going to be just a memory because it's not going to be here, might depend on the ability we have to memorize or to transfer the biosphere to somewhere else. The notion of wilderness has to be injected into this notion that eventually the biosphere is going.

JC: But that's a long time away.

Soleri: If we want to find a meaning in what now exists we have to pull in the whole of reality. Possibly that meaning is so exciting and so im-

mensely beautiful that we should work with it, even if we don't know what it is now, as yet.

JC: In your presentation, you've related ideas in a very global scale and also inferred the importance of three-dimensional thinking. You've looked at things with a very long time-frame. You haven't referred much to the immediacy except in terms of the stuff that's right under our nose. Do you have any thoughts about the loss of nature, which is already visible? The melting of the polar caps? The holes in the ozone layer? I assume that your concept of our human responsibilities take account of those immediate effects of nature. But you haven't discussed them.

Soleri: Well, the fact that the climate has been altered is a consequence of consumption. There is another kind of consumption that we are developing now because we are coming up with cleaner industries. But we went through a period where industry was really dirty, and now China, for instance, is an example of what you might call dirty technology. But we went through that, and the fact remains that our consumption is so high that we are still the most pollutant nation on Earth. So notwithstanding the skill and the subtleties and the high quality of technology, we are demanding so much from the planet that we are still damaging it. There again, putting a ceiling to our consumption is something that is becoming mandatory. That is reflected by things that are very, very simple, very elementary. If I have a box of Kleenex here, and I pull one Kleenex out and blow my nose and throw it away, multiply that by 5 billion people and you find out that Kleenex is a forest. So I should do something about that and every single act of our daily routine covers this fact of consumption. The bigger our abodes, the bigger our consumption. It's inescapable.

JC: So as an architect, you're really advocating a kind of dematerialization as a goal for future generations.

Soleri: I compare this country with Europe, for instance, where there

are apartments. They are very elegant, very sophisticated, and very good in many ways. Instead of looking in the back yard of your neighbor, you look twenty miles this way and five miles that way. So the resistance, almost the revulsion that we have for apartments might have to change. We might have to think in terms of no longer living in my bungalow, but living up there in a very sophisticated space.

Index

Contacting Cosanti and Arcosanti

For more information about Cosanti, Paolo Soleri's workshop, foundry, and gallery in Scottsdale, Arizona, please contact:

Cosanti
6433 Doubletree Ranch Road
Scottsdale, Arizona 85253
(480) 948-6145

For more information about Arcosanti, Soleri's prototype arcology in Cordes Junction, Arizona, including workshops, conferences, concerts and internships, please contact:

Arcosanti
HC 74 Box 4136
Mayer, AZ. 86333
Telephone: (520) 632-7135
Email: arcoinfo@arcosanti.org

Information is also available at the Arcosanti website:

www.arcosanti.org